Mirko Martin

Tales from the West Side

Mit freundlicher Unterstützung/**Kindly supported by**

Mirko Martin

Tales from the West Side

KERBER
PhotoART

Vorwort

Als Stipendiat des DAAD verbrachte Mirko Martin, nach 2005/06, in diesem Jahr zum zweiten Mal einen längeren Arbeitsaufenthalt in Los Angeles.

Die in der losen Serie »L.A. Crash« zusammengefassten Fotoarbeiten des Künstlers schildern Szenen, die uns vertraut erscheinen. Wir kennen die Motive der Großstadt, die Polizisten und Festnahmen auf offener Straße oder die Helikopter zwischen den Wolkenkratzern aus zahlreichen Filmen und Erzählungen. Mirko Martin spielt mit diesen uns bekannten Motiven und stellt sie wie Episoden aus einem Film nebeneinander. So wirken sie wie Standbilder aus unterschiedlichen Filmen und bedienen zunächst unser Klischee von Los Angeles und der Westküste.

Dies ist aber nur eine erste Leseart dieser Fotos. Mirko Martin greift bei seinen Bildmotiven sowohl auf Filmsets als auch auf reale Ereignisse zurück. Durch eine bildnerische Verdichtung der Geschehnisse sowie die nachträgliche Zusammenstellung der Aufnahmen lässt er jene Realität entstehen, die es uns unmöglich macht, zwischen Wahrheit und Fiktion zu unterscheiden. Im Werk des Künstlers durchdringen sich beide Ebenen so selbstverständlich und unsichtbar, dass der Betrachter mit der Frage konfrontiert wird »welche Art von Wahrheit den Fotografien entnommen werden kann«, so Mirko Martin.

Martin erzählt, mit seinen Fotografien als auch mit seinen Videoarbeiten, Geschichten. Im Video »Noir« von 2008 beispielsweise, erzählt er die Geschichte einer Nacht als Dialog zwischen ihm und einem Nachbar. Beide lauschen der Polizeiaktion im Stadtviertel. Das Video verzichtet auf die Bilder und beschränkt unsere Wahrnehmung allein auf den Ton. Wie in den Fotoarbeiten bewegt sich Martin auch hier in einem Raum zwischen Fiktion und Realität, der vom Betrachter sehr individuell gedeutet werden kann und unsere Wahrnehmung in Frage stellt.

Wir danken Mirko Martin für die Konzeption der Ausstellung und dieses Buches, das gestalterisch in den bewährten Händen von Christina Hackenschuh und ihrem Team lag. Ganz besonders danken wir Viola Weigel von der Kunsthalle Wilhelmshaven für die freundliche Vermittlung sowie Martin Engler für seinen Textbeitrag.
Die Sparkasse Goch-Kevelaer-Weeze hat die Finanzierung des Buches übernommen, wofür wir ihr sehr herzlich danken.

Stephan Mann

Preface

After 2005/06, Mirko Martin paid a second long working visit in 2008 to Los Angeles on a scholarship from the German Academic Exchange Service.

The photographic works by the artist composing the loose series "L.A. Crash" show scenes that seem familiar to us. We know the big city themes, the policemen and arrests on the open street or the helicopter between skyscrapers, from innumerable films and stories. Mirko Martin plays with these familiar motifs, juxtaposing them like episodes in a film. They give the impression of being stills from different films, initially confirming our cliché thinking about Los Angeles and the West Coast.

But this is only the first way these photos can be read. Mirko Martin draws his subject matter from both film sets and real events. Through the pictorial concentration of events and the subsequent compilation of the pictures, he creates a reality where it is impossible to distinguish between truth and fiction. In the work of the artist, the two levels interpenetrate with such self-evidence and so imperceptibly that the observer cannot avoid asking, as Mirko Martin puts it, "what sort of truth can be learned from the photographs."

In his photographs, as in his video works, Martin tells stories. In the 2008 video "Noir," for instance, he tells the story of a night as a dialogue between himself and a neighbour. The two are listening to police action in the neighbourhood. The video does without pictures, limiting our perception to sound alone. As in his photographic works, Martin operates in a space between fiction and reality which can be very individually interpreted by the viewer and which calls our perception into question.

We thank Mirko Martin for the conception of the exhibition and this book; the design of which has been entrusted to the worthy and reliable hands of Christina Hackenschuh and her team. Our particular thanks go to Viola Weigel of the Kunsthalle Wilhelmshaven for her friendly mediation and to Martin Engler for his text contribution.
The Sparkasse Goch-Kevelaer-Weeze has financed the book, for which we express our heartfelt gratitude.

Stephan Mann

Die schizophrene Stadt

Es könnte ein Ballett sein. Heranwachsende, etwa ein Dutzend, bewegen sich vor der Kamera. Ihre Köpfe, gelegentlich Hände, Oberkörper oder Arme werden von der Kamera eingefangen: Goldkettchen, modisch uniforme Kurzhaarschnitte, eine Baseball-Mütze, Tattoos – aus dem Einerlei der T-Shirts fällt nur ganz zu Anfang ein gestreiftes Polo-Hemd heraus. Die Köpfe kommunizieren, allerdings auf eine seltsam ritualisierte Art und Weise über Gesten und Blicke. Gesprochen wird eher selten, und wenn, dann sieht es nach Schreien oder einer Form von Gesang aus. Die kurzen, banalen Handlungsmomente, ihre martialischen Gesten, die juvenile Mimik wird durch eine extreme Zeitlupe theatralisch gedehnt. Der siebenminütige Video-Loop kommt gänzlich ohne Ton aus, trotzdem meint man den harten Beat, der den Raum erfüllt, fast körperlich zu spüren.

Der Ort, ein Innenraum, doch auch das wird nur beiläufig deutlich, bietet keinerlei Anhaltspunkt, mit der die Handlung oder ihr Zweck einsichtig würde. Der Hintergrund, im konkreten wie im übertragenen Sinn, bleibt nichtssagend: ein abwechselnd schwarzer oder weißer Umraum, den nur ein backsteinfarbener Gewölbeansatz und ein rotes Feuerlöscherzeichen von einer Bühne zu unterscheiden scheinen. Denn das ist die zentrale Frage in dem Video **Flow** (2007) (Abb. S. 8, 14) wie generell in den Arbeiten Mirko Martins: Was wird hier gespielt und für wen, welcher Inszenierung wohnt die Film- oder Fotokamera bei, wer ist Adressat der Kommunikation, und vor allem – ist die Kamera und damit der Künstler Teil oder Beobachter des Geschehens? Es ist die Frage nach Nähe und Distanz zwischen Leben und Ästhetik, zwischen dem Künstler und dem Objekt seiner Kunst.

Während **Flow** konsequent mit der Abwesenheit jeglicher Narration spielt, Kommunikation auf eine Folge abstrakter Gesten verkürzt, inszenieren die Fotoarbeiten von **L. A. Crash** (2006–2008) ein Überangebot narrativer Details. Nicht die Leere eines vermeintlichen Bühnenraums wird evoziert, sondern eine Überfülle von Verweisen und Bedeutungen. Bühne ist hier der Stadtraum von Los Angeles. Die Handlung spielt mit der cineastischen Lust an der Katastrophe ebenso wie mit der alltäglichen Katastrophe des Molochs Stadt, seiner Obdachlosen und seinen urbanen Unorten.

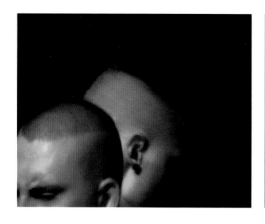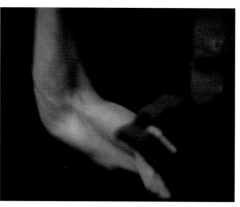

Das Setting ist auf den ersten Blick idyllisch und gesichtslos im gediegenen Cinemascope-Format (Abb. S. 56/57): Gepflegter, gut gewässerter Rasen, hohe Palmen, im Hintergrund ein blauer Streifen weites Meer. Der Vordergrund ist auf den zweiten Blick Ort eines Unfalls, Anschlags, Verbrechens oder irgendeines anderen katastrophischen Geschehens. Wie hingestreckt liegen mehrere Menschen leblos auf Rasen und Bürgersteig. Die Protagonisten, barfuß und in Alltagskleidung, werden von der Kamera angeschnitten, um sie zum Teil eines größeren, unüberschaubaren Ganzen zu machen. Doch schon unmittelbar neben dem ›crime site‹ beginnt wieder eine andere Realität. Das Bild und seine Handlung werden brüchig: Die einheitlich roten Rücksäcke, die unmittelbar neben den vermeintlich Toten liegen, erzählen eine andere Geschichte. Sie irritieren zumindest das unverbundene Nebeneinander von Katastrophe und Idylle, von Hinter- und Vordergrund. Wobei auch im Mittelgrund des Bildes Menschen liegen. Diese aber nicht leblos und von einer höheren Gewalt hingestreckt, sondern schlafend und entspannt in der kalifornischen Sonne sich räkelnd.

Was wir sehen ist eine Aufnahme von einem Filmset in Los Angeles, wo täglich nicht selten 100 Drehs stattfinden. Ein zweiter Shot vom gleichen Set scheint den Befund zu erhärten, liefert vielleicht sogar die Ursache für das irritierende Geschehen, macht die Surrealität aber nur noch offensichtlicher (Abb. S. 55): Dieser zweite Shot suggeriert, dass ein sonderlicher Alien die Jugendlichen zu Fall bringt. (Martin klärt uns glücklicherweise nie über die Qualität der Filme auf; hier zweifelsohne ein Film der Kategorie B-Movie.) Im Hintergrund sitzt eine ältere Frau breitbeinig im Schatten. Sie nimmt im Gegensatz zu uns von der Handlung im Vordergrund keinerlei Notiz. Es ist dieses manchmal kaum merkliche, manchmal ildkonstituierende Auseinanderfallen der Realitätsebenen, das die Arbeiten Martins so irritierend und im positiven Sinne merkwürdig macht: Ein unsichtbarer Riss verläuft durch diese Inszenierungen, der die urbanen Räume von einander scheidet, ohne dass dies an der Oberfläche der Bilder ablesbar wäre. Es ist vielmehr die Art und Weise, wie sich die – mehr oder weniger freiwilligen – Protagonisten zu diesem Raum verhalten, wie sie ihn besetzen und in ihm agieren, die deutlich macht, dass es hier explizit um die soziologische Beschaffenheit dieses öffentlichen Raumes geht.

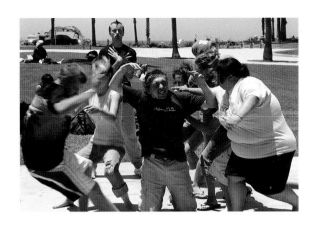

Dieser Moment der politischen Verfasstheit unserer urbanen Lebenswelt gerät umso mehr in den Fokus, wenn uns Mirko Martin plötzlich auf völlig andere Handlungsfelder führt. Wir verlassen mit ihm und seinem Kamera-Auge die Hollywood-Traumwelt und stoßen auf gänzlich andere Verwerfungen des städtischen Lebensraums. Die Aufnahmen aus Downtown Los Angeles, die während zweier Aufenthalte in den Jahren 2006 und 2008 entstanden, spielen nur zum Teil auf einschlägigen Filmsets. Ein paralleler Handlungsstrang entwickelt sich entlang der realen Verwerfungen des alten Stadtzentrums, das durch massive Bevölkerungsmigrationen, Rassenunruhen und durch die Flucht der ursprünglichen weißen Bewohner in die Suburbs regelrecht implodierte. Ein überaus spannender soziologischer Prozess, der nicht zuletzt die Amerikanische Literatur von Don de Lilo bis Jeffrey Eugenides wesentlich befeuert und die Problematiken der amerikanischen Gesellschaft in seltener Schärfe formuliert. Hier finden sich nun in unmittelbarer Nähe »Skid Row«, eine der größten Obdachlosenansammlungen der Vereinigten Staaten, wo in einem etwa 50 Häuserblocks umfassenden Gebiet Tausende von Menschen auf der Straße leben, sowie ein Großteil der famosen Filmsets. Der gemeinsame Nenner ist in beiden Fällen das Katastrophische sowie das Nebeneinander diametral entgegen gesetzter Realitätsbezüge. Dass die Orte von »fiction« und Realität dieselben sind, ist Programm, die Ununterscheidbarkeit mehr als nur Zufall.

Beide Handlungsstränge von **L. A. Crash** handeln von Unfällen und Unglücken, Zerstörung und Gewalt. Und natürlich ist die zynische Spannung zwischen der gespielten Tragödie und ihrem realen Doppel in der angrenzenden Seitenstraße in jedem Moment nur allzu schmerzhaft präsent. Dabei ähneln sich die Szenen, die Mirko Martin uns vorstellt, noch sehr viel mehr, als es auf den ersten Blick den Anschein hat. Nicht nur die Thematiken konvergieren auf erstaunliche Weise, sondern auch die innere Struktur der Bilder trägt neben der topographischen Nähe wesentlich zur Ununterscheidbarkeit der eigentlich vollkommen gegensätzlichen Bildwelten bei. Eine, im Gegensatz zu den beiden schon besprochenen Arbeiten, während des zweiten Aufenthalts entstandene Aufnahme bestätigt diesen Befund. (Abb. S. 58/59) Obwohl sie, wie wir vermuten, nicht auf einem Filmset entstanden ist, weist sie die identische schizophrene Spaltung der Realitäten auf, wie wir sie oben schon beschreiben konnten. Wohl gemerkt, unter gänzlich anderen Auspizien.

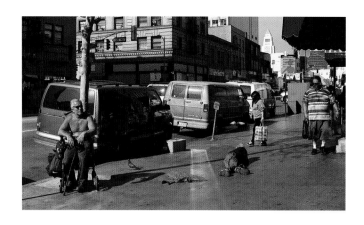

Im Bildmittelgrund kriecht ein Mann quer über den Bürgersteig. Das Setting ist kleinstädtisch, heruntergekommen, Downtown L. A. eben. Eine warme Abendsonne beleuchtet eine verstörende Szenerie: Der am Boden Liegende ist von drei weiteren Protagonisten umgeben. Während eine Frau mit seltsamer Gesichtsmaske (der einzige Moment, der dann doch an ein Filmset denken lässt) unbeeindruckt ihren Weg fortsetzt und ein Mann im Rollstuhl überhaupt keine Notiz nimmt, scheint der dritte Passant zumindest flüchtiges Interesse aufzubringen. Am stärksten ist allerdings der Kontrast zwischen dem mit bloßem Oberkörper sich sonnenden Rollstuhlfahrer und jenem hinter ihm hilflos Hingestreckten.

Ähnlich wie am Filmset der vorhergehenden Arbeiten geht an dieser Stelle ein unsichtbarer Riss durch die scheinbar kongruente Realität des Bildes. Mit der fatalen Differenz, dass der Protagonist im Bild sein eigenes Leben ›spielt‹ und am Ende des Takes nicht fröhlich aufspringen mag. Eine ebenso faszinierende wie irritierende Szene aus David Lynch's rabulistisch fabulierendem Kino-Epos **Inland Empire** scheint hier Pate zu stehen: Am Ende eines langen Takes, eines Gesprächs zweier Obdachloser, an dessen Ende einer der beiden Protagonisten stirbt, steht der zweite Schauspieler auf und geht. Der Film aber läuft weiter, das erlösende »Cut« wird zwar aus dem Off gerufen, nur der am Ende des Dialogs Gestorbene bleibt liegen. Die Kamera zoomt immer weiter weg vom Schauplatz des unerhörten Ereignisses. Der Kintopp scheint plötzlich seine zentrale Fähigkeit verloren zu haben: die Illusionsmaschine ist tot! Fiktion und Realität, Kunst und Leben fallen mit einem Mal in eins, allerdings mit einer beunruhigend bodenlosen Konnotation.

Die Foto-Arbeiten von Mirko Martin gewinnen so eine Qualität der medialen Reflektion, die über das Spiel zwischen Film und Realität, zwischen Hollywood und den beispielsweise in Mike Davis' **City of Quartz** anschaulich beschriebenen Ursachen des urbanen Verfalls in Los Angeles weit hinausgeht. Das »Hic et nunc« der dokumentarischen Fotografie, dieses, wie die Minimal Art sagen würde, »What you see is what you get«, des fotografischen Bildes, ist endgültig verloren. Es geht nicht mehr um das Abbilden und Bewahren eines vergänglichen Moments. In den nur marginal sich verschiebenden Blickpunkten Mirko Martins wird vor allem auch der Blick des Betrachters reflektiert. Unser Umgang und unser Blick auf das, was sich außerhalb der Kunst ereignet, wird in ernüchternder Weise seziert. Im Zwiespalt identischer Katastrophen, im Nebeneinander identischer Settings, die auf vollkommen

getrennte Realitätsebenen verweisen, scheint eine verwirrende Analogie auf: Was Martin uns vorführt, ist eine Parabel über die Möglichkeiten und die Bedingtheit einer Kunst, die ihr Augenmerk auf Momente sozialer und politischer Realität richtet.

Die Parallelität der Blickpunkte macht den realen Obdachlosen ebenso wie den Protagonisten des Filmsets zum Subjekt unseres soziologischen Blicks. Die Künstlichkeit und das Voyeuristische des Blicks der Hollywood-Kamera wird von der Digitalkamera Mirko Martins gedoppelt und im Ergebnis unsere Betrachterhaltung und die des Hollywood-Films parallelisiert. Nicht eine identische Haltung wird den beiden Kamerablickpunkten unterstellt, sondern eine Äquidistanz zu ihrem Objekt. In beiden Fällen bleiben die Ebenen von Kunst und Politik, Fiktion und Realität säuberlich getrennt. Das Ende des »Hic et nunc« der Fotografie bedeutet auch, dass es den dokumentarisch-involvierten Blick des Fotografen nicht mehr gibt und der Fotograf immer auch (digitaler) Choreograph seiner Bilder und Darsteller ist. In einem befremdlichen Spiel zwischen Distanz und Nähe bleiben Künstler wie Betrachter doch immer interesselose Beobachter, die selbst den Riss der Realitätsebenen verkörpern. Und wie in Lynchs **Inland Empire** bleibt einer am Ende im Bild zurück – und es ist nicht der Betrachter.

Martin Engler

The Schizophrenic City

It could be a ballet. Adolescents, about a dozen of them, move about in front of the camera. Their heads, sometimes their hands, torsos or arms are caught by the camera: gold chains, fashionably uniform short haircuts, a baseball cap, tattoos – the t-shirt monotony interrupted only at the very beginning by a striped polo shirt. Heads communicate, albeit in a strangely ritualised manner by gesture and glance. There is little talk, and when something is said it looks like screaming or a form of singing. The brief, banal moments of action, the martial gestures, the juvenile mimicry are theatrically stretched in extreme slow motion. The seven-minute video loop renounces all sound; nevertheless, the hard beat that fills the room can be almost physically sensed.

The setting, an interior space – as we discover only incidentally – offers no clue about the action or its purpose. The background, in both the concrete and figurative sense, betrays nothing: alternatively black and white surroundings, distinguishable from a stage only by the brick-coloured shoulder of an arch and a red fire extinguisher sign. For this is the key question in the video **Flow** (2007) (fig. p. 8, 14) and generally in the works of Mirko Martin: What is being performed and for whom? What is the event the camera is trained on? Who is the addressee of the communication? And, above all, is the camera and hence the artist part of what is happening or an observer? It is a question of proximity and distance between life and aesthetics, between the artist and the subject of his art.

While **Flow** consistently plays with the absence of any narration, reducing communication to a sequence of abstract gestures, the photographic works composing **L. A. Crash** (2006–2008) provide an over-abundance of narrative detail. It is not the emptiness of a supposed stage that is evoked but a profusion of indications and meanings. The stage is downtown Los Angeles. The action plays with the cinematic love of disaster and the everyday catastrophe of the Moloch city, its homeless hordes and urban non-places.

At first glance, the setting is idyllic and anonymous in classical Cinemascope format (fig. pp. 56/57): well-kept, well watered lawn, high palms, in the background a blue strip of distant ocean. At second glance, the foreground is the scene of an accident, attack, crime, or some other catastrophic event. Several people are lying, lifeless victims, on lawn and

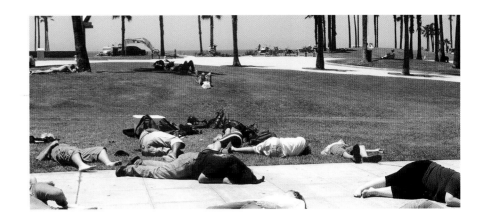

sidewalk. The protagonists, barefoot and in everyday clothing, are cut by the camera to make them part of a larger, enormous whole. But immediately beside the 'crime site' another reality begins. The picture and its action begin to come apart: the uniformly red backpacks lying directly next to the supposed bodies tell another story. They disturb at least the unconjugated juxtaposition of disaster and idyll, background and foreground. In the middle ground, too, there are people lying. But they are not lifeless, felled by some higher power; they are stretched out asleep, relaxing in the Californian sun.

What we are looking at is a picture of a filmset in Los Angeles where 100 shoots can take place per day. A second shot of the same set seems to confirm the finding, perhaps even revealing the cause of the puzzling happenings, but making the surreality even more apparent (fig. p. 55): this second shot suggests that a weird alien has killed the young people (Martin fortunately never informs us about the quality of the films; in this case a B movie is doubtless involved). In the background an elderly woman is sitting legs apart in the shade. In contrast to ourselves, she takes no notice whatsoever of the action in the foreground. It is this sometimes scarcely perceptible, sometimes constitutive dislocation of reality levels that makes Martin's works so intriguing and in a positive sense peculiar: an invisible fissure traverses these stagings, separating urban spaces from one another without it being legible on the surface of the pictures. It is more the way in which the – more or less voluntary – pro-tagonists behave towards this space, how they occupy it and act in it, that shows we are concerned explicitly with the sociological properties of this public space.

This moment in the political organisation of our urban lifeworld comes even more strongly into focus when Mirko Martin suddenly takes us into completely different areas of action. With him and his camera eye we leave the Hollywood dream-world to encounter completely different faults in the urban environment. Only some of the shots from downtown Los Angeles taken during two visits in 2006 and 2008 are located on filmsets. A parallel line of action develops along the real faults of the old city center, which utterly imploded in the aftermath of massive population shifts, racial riots and the exodus of the original white residents to suburbia. A highly interesting sociological process, which has not least inspired American literature from Don de Lillo to Jeffrey Eugenides, expressing the problems of

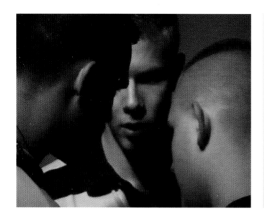 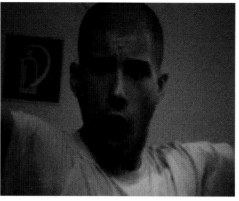

American society with rare clarity. Skid Row, one of the biggest concentrations of homeless people in the United States, where thousands of people live on the streets in an area covering about 50 blocks, exists cheek-by-jowl with most of the famous filmsets. The common denominators in the two cases are disaster and the juxtaposition of diametrically opposing realities. That the places of fiction and reality are the same is programmatic; if they are indistinguishable it is not by mere chance.

The two lines of action in **L. A. Crash** deal with accidents and calamities, destruction and violence. And, naturally, the cynical tension between enacted tragedy and its real-world counterpart in the streets alongside is all too painfully present in every moment. The scenes that Mirko Martin presents resemble one another very much more than is apparent at first glance. Not only does the subject matter converge astonishingly; the inner structure of the pictures, in addition to the topographical proximity, contributes greatly to the indistinguishability of the completely opposing image worlds. One picture, which, unlike the works discussed above, was taken during the second visit, confirms this. (fig. pp. 58/59). Although, as we suppose, it was not made on a filmset, it shows exactly the same schizophrenic split in reality that we have described. Albeit under completely different auspices.

In the middle ground a man is crawling across the sidewalk. The setting is small-town, dilapidated: downtown L.A. A warm evening sun illuminates a distressing scene: the man on the ground is surrounded by three further protagonists. While a woman wearing a strange mask (the only moment that recalls a filmset) passes by unimpressed and a man in a wheelchair takes no notice at all, the third passer-by seems to be taking a least a fleeting interest. However, the strongest contrast is between the man in the wheelchair, sunning himself with bare torso, and the helpless figure on the ground behind him. As on the filmset of the previous works, an invisible split passes at this point through the seemingly congruent reality of the picture. With the fatal difference that the protagonist in the picture is "acting" his own life and cannot cheerfully jump to his feet when the take is finished. A both fascinating and irritating scene from David Lynch's sophistically yarn-spinning cinematic epic **Inland Empire** seems to have been the model: at the end of a long take, a conversation between two homeless people, following which one of the two protagon-

ists dies. The second actor gets up and goes. But the film continues, the liberating "Cut!" is called off screen, only the character who had died after the end of the dialogue remains lying. The camera zooms farther and farther away from the scene of the outrageous event. The cinema seems suddenly to have lost its key ability: the illusion machine is dead! All at once, fiction and reality, art and life coincide, albeit with a disturbingly appalling connotation.

The photographic works of Mirko Martin thus develop a quality of reflection on the media that goes far beyond the play between film and reality, between Hollywood and the causes of urban decay in Los Angeles described, for example, in Mike Davis' **City of Quartz.** The here-and-now of documentary photography, this, as minimal art would say, "What you see is what you get" of the photographic image, is finally lost. It is no longer a matter of capturing and preserving a transitory moment. The only marginally shifting viewpoints of Mirko Martin reflect above all the perspective of the viewer. How we deal with, how we look at what happens outside art is soberly dissected. In the conflict between identical disasters, in the juxtaposition of identical settings that point to completely separate levels of reality, a bewildering analogy appears: what Martin presents us with is a parable on the possibilities and contingency of an art that gives its attention to moments of social and political reality.

The parallelism of viewpoints makes the real homeless just as much as the filmset protagonists objects of our sociological scrutiny. The artificiality and voyeurism of the Hollywood camera perspective is doubled by Mirko Martin's digital camera, placing our position as viewer and that of the Hollywood film in parallel. This is not to say that the two camera perspectives adopt an identical attitude, but that they are equidistant from their object. In both cases the levels of art and politics, fiction and reality are kept neatly separate. The end of the here-and-now of photography also means that the documentarily involved photographer's eye no longer operates; the photographer is both (digital) choreographer of his pictures and actor. In a strange play between distance and proximity, the artist, like the viewer, remain disinterested observers, who themselves embody the split in reality levels. And, as in Lynch's **Inland Empire,** one figure remains behind in the picture at the end – and it is not the viewer.

Martin Engler

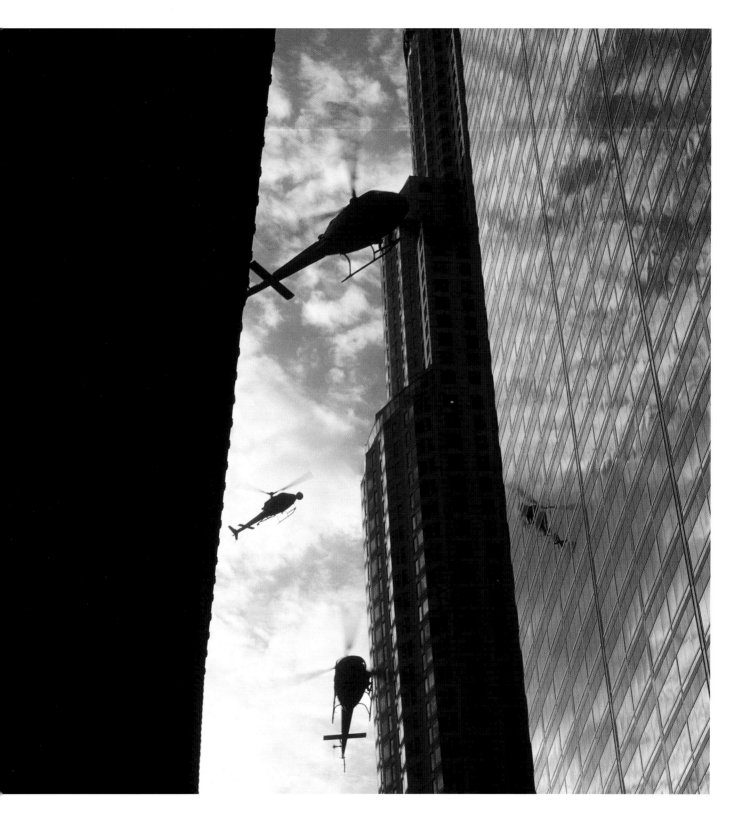

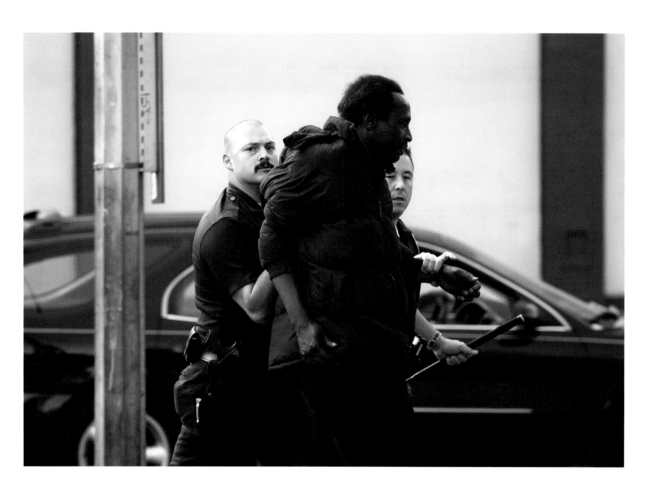

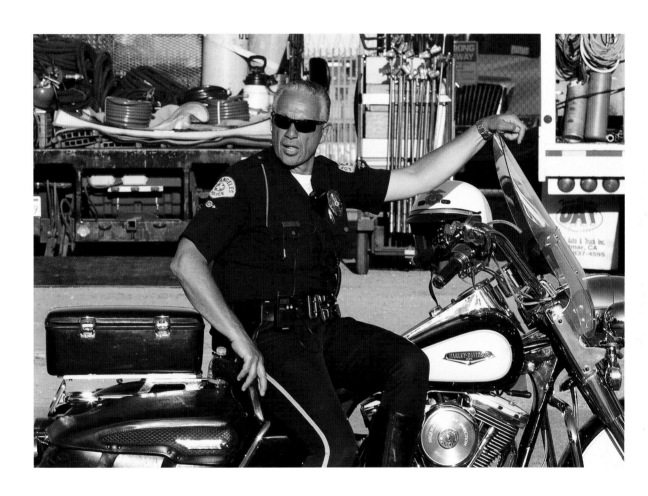

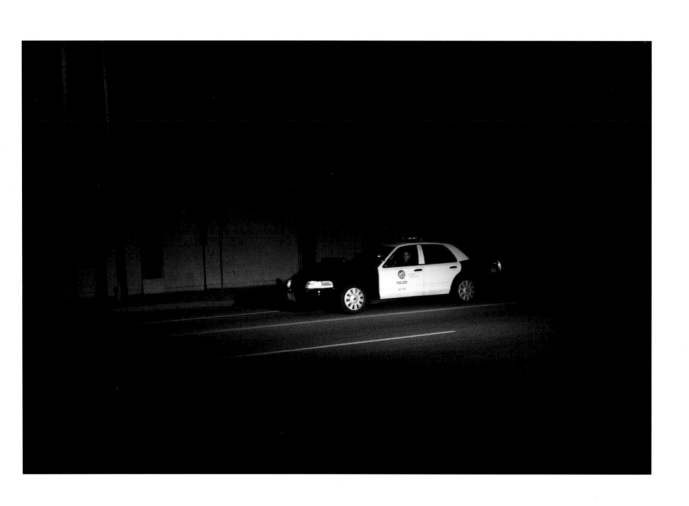

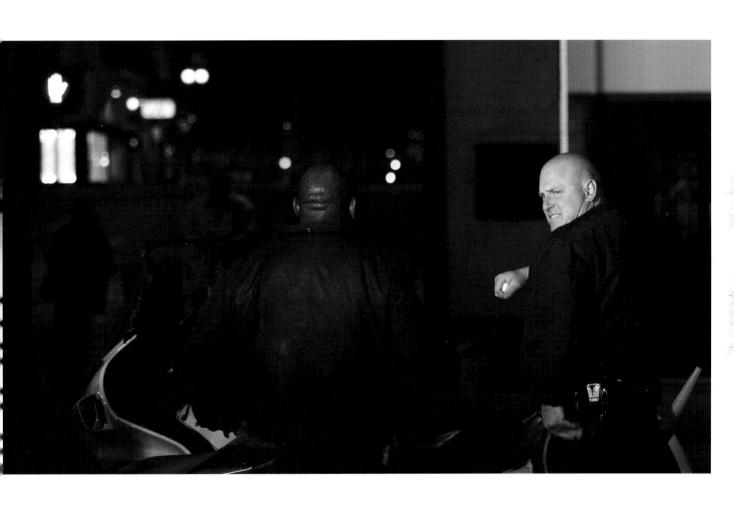

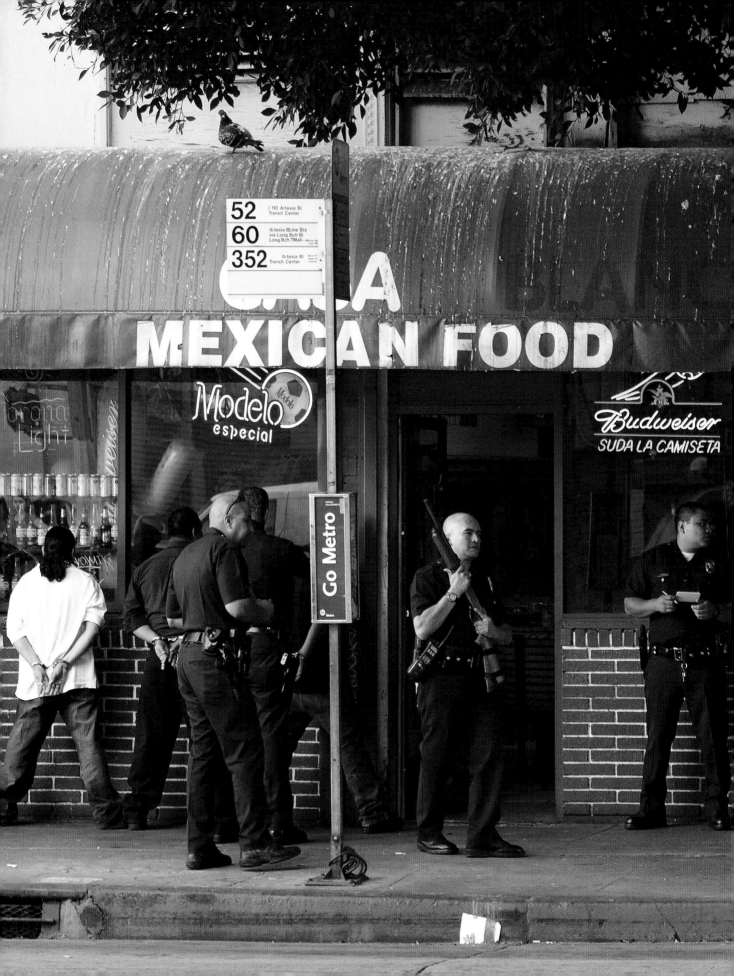

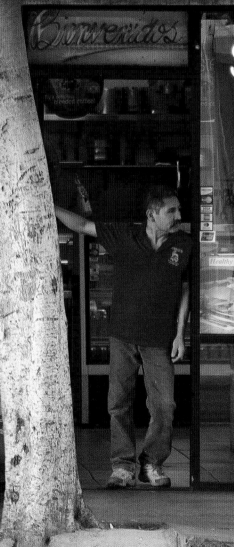

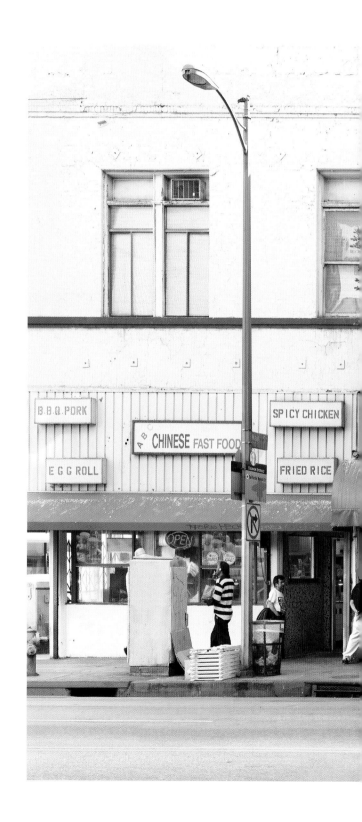

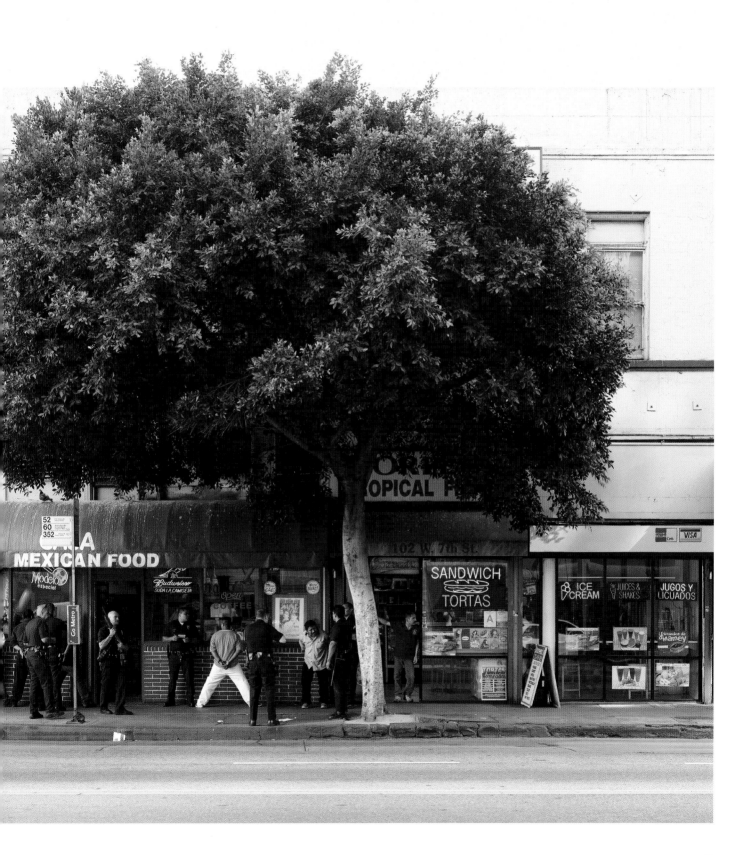

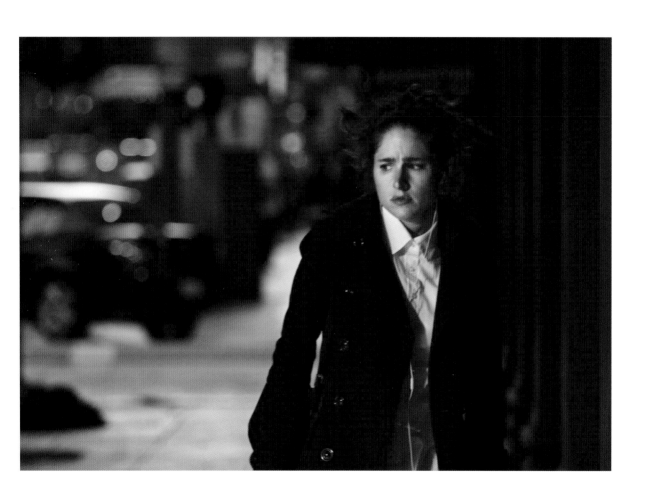

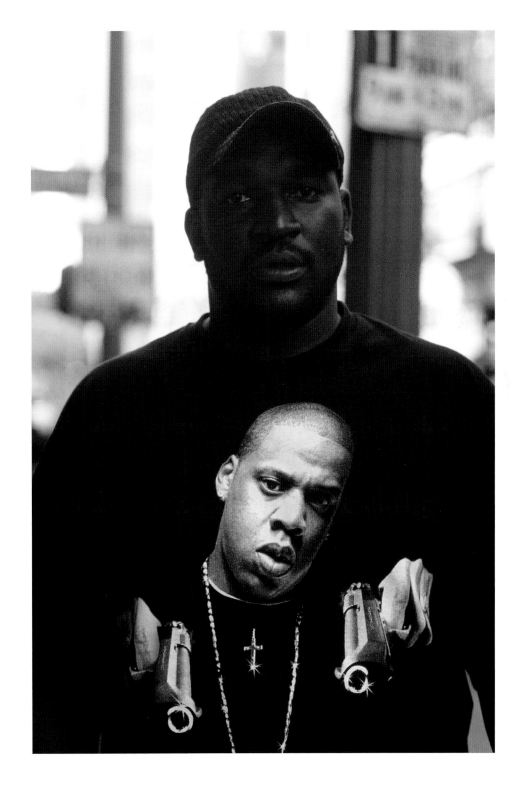

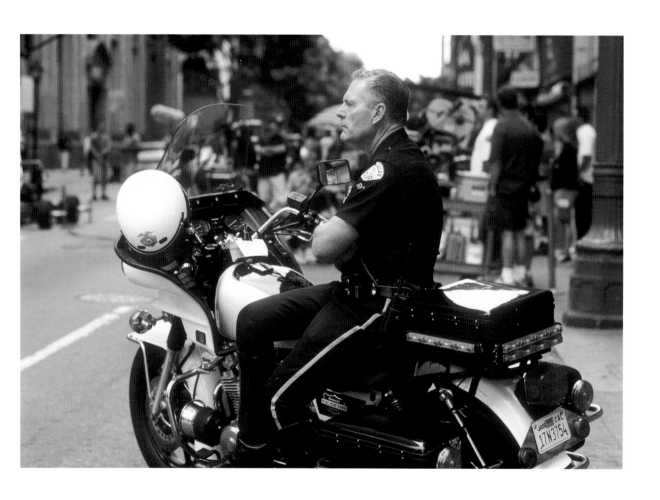

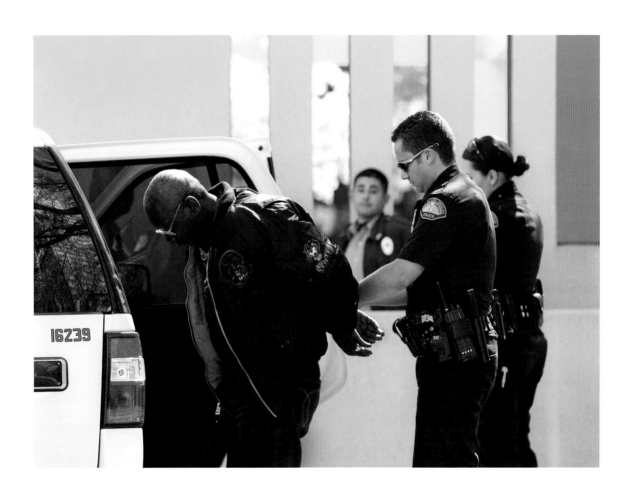

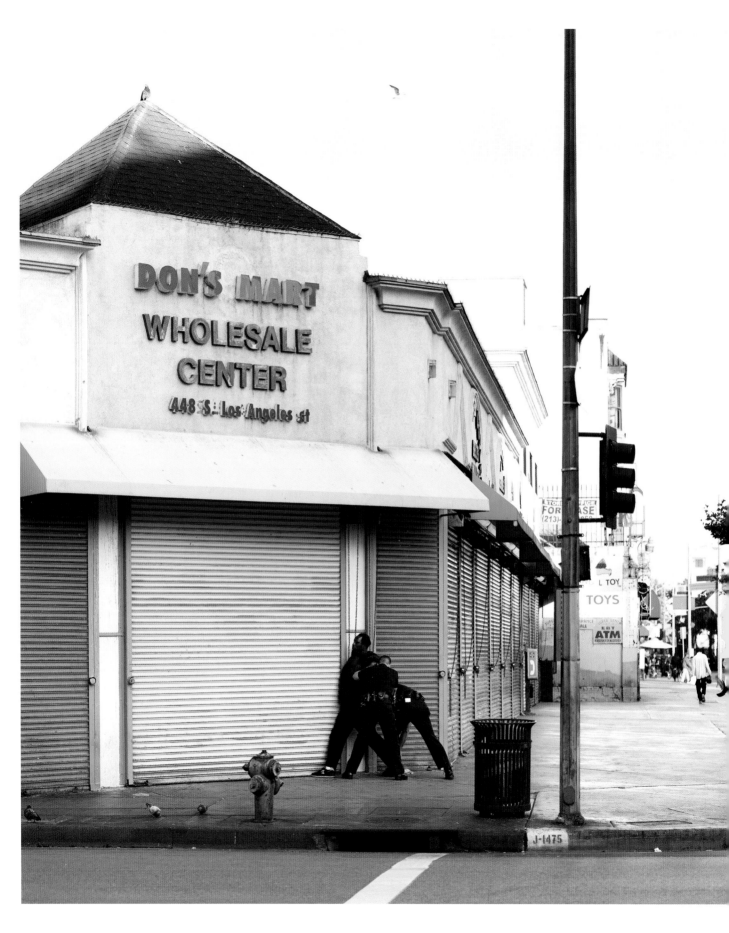

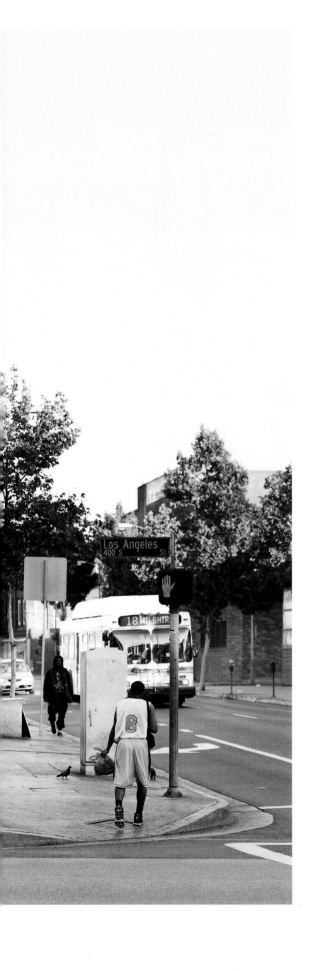

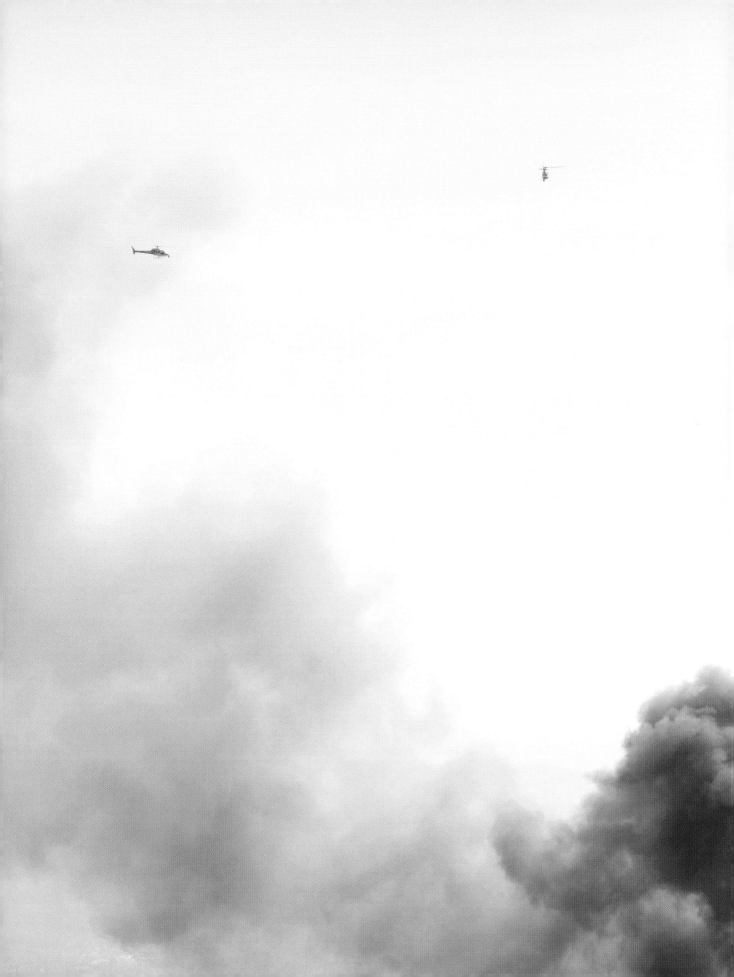

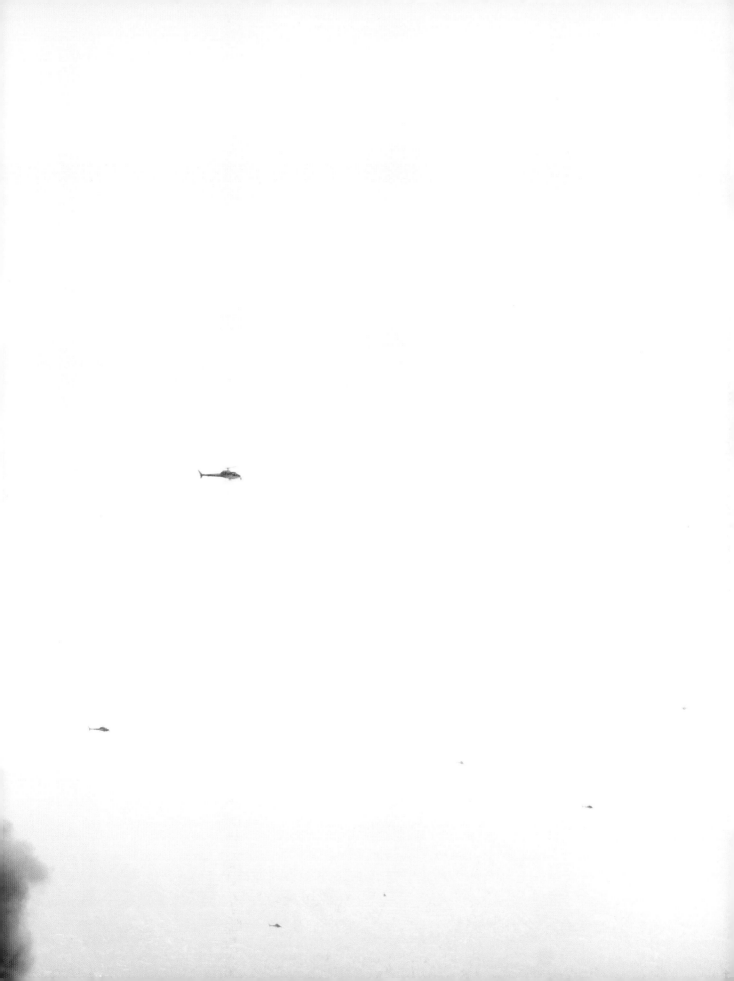

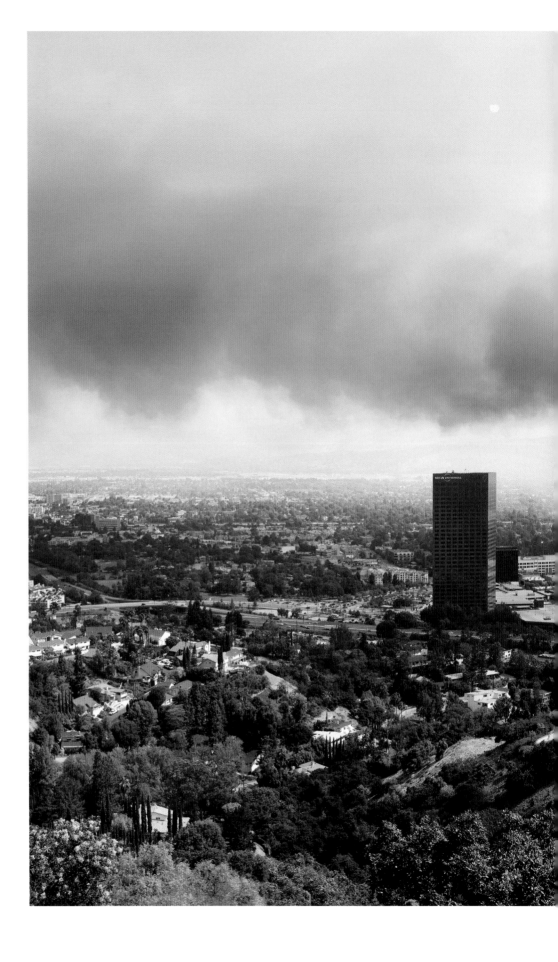

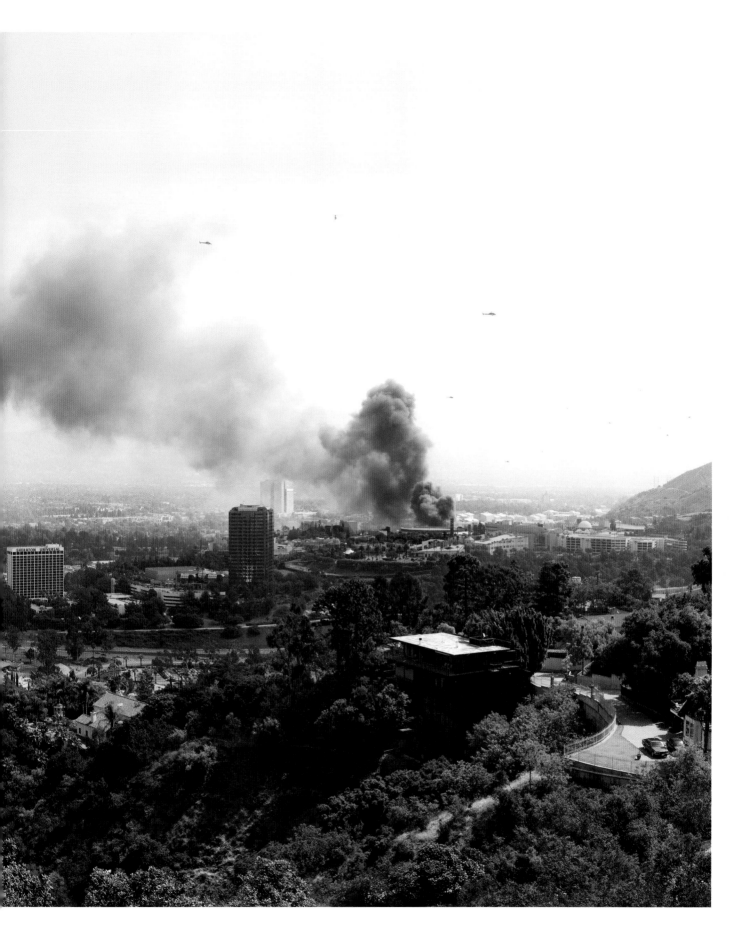

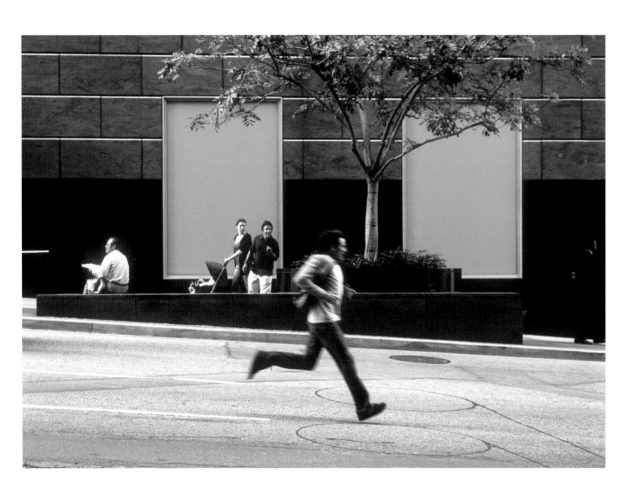

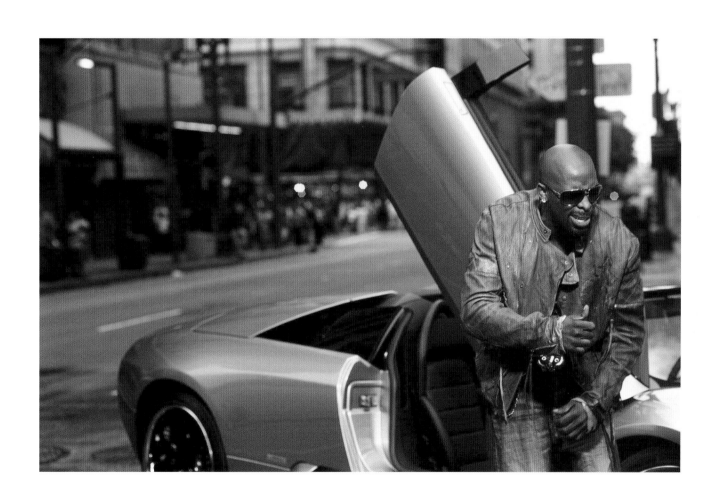

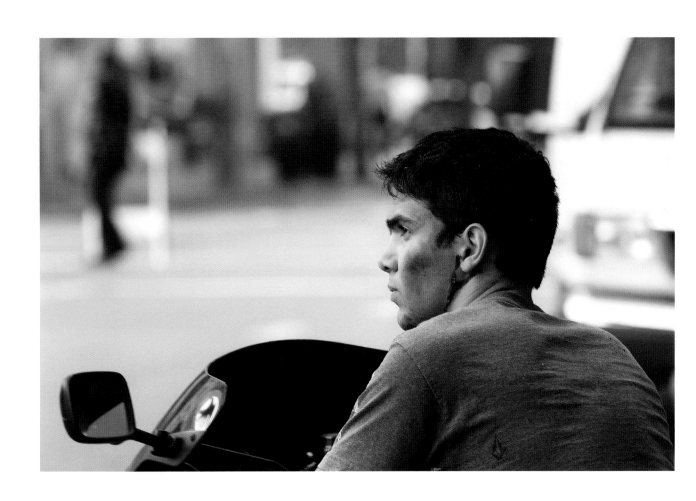

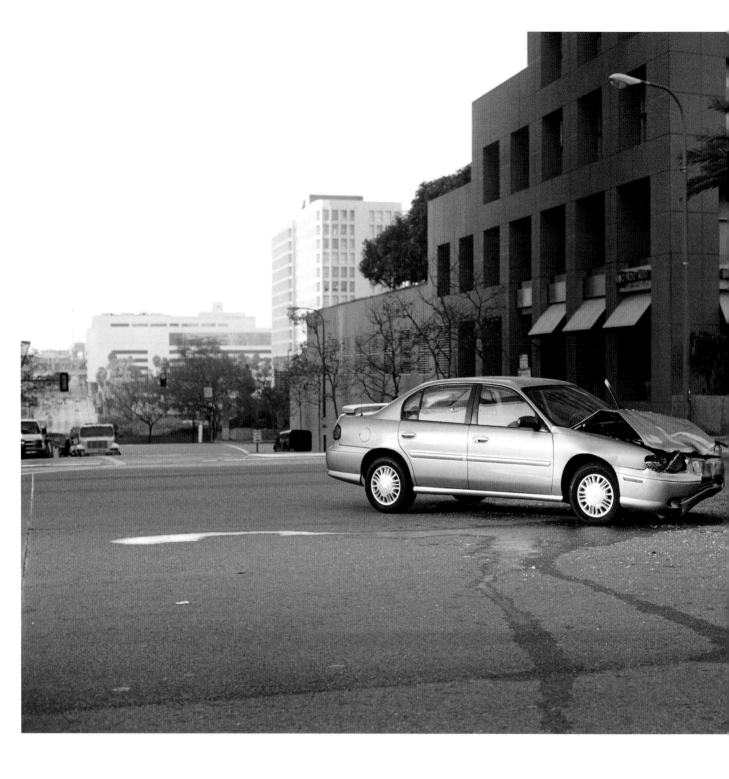

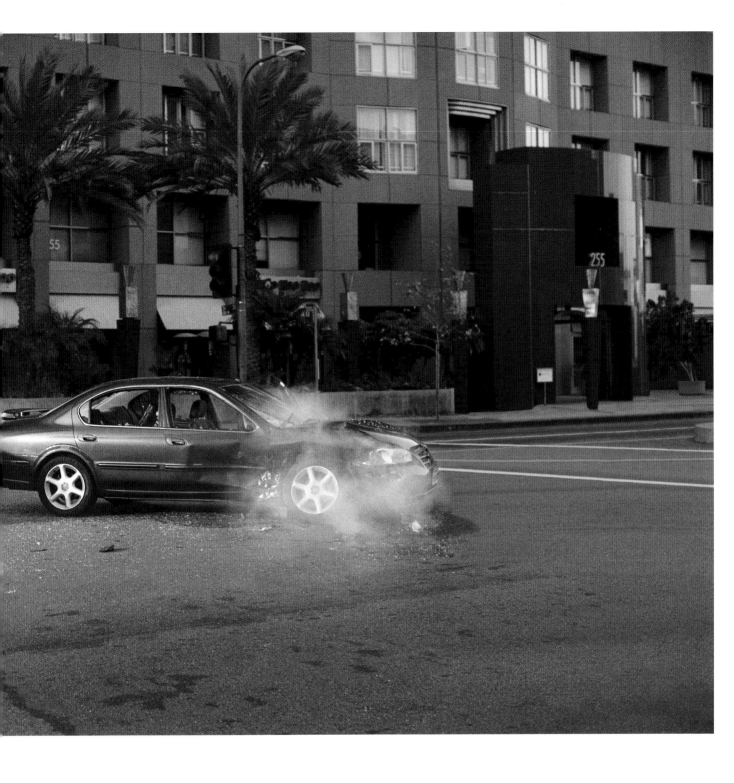

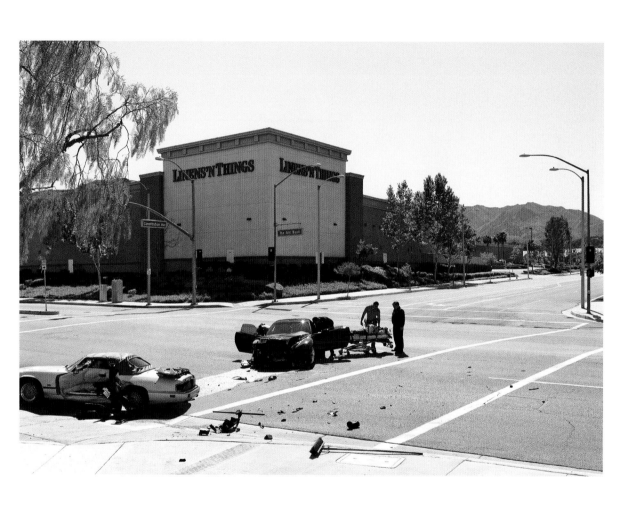

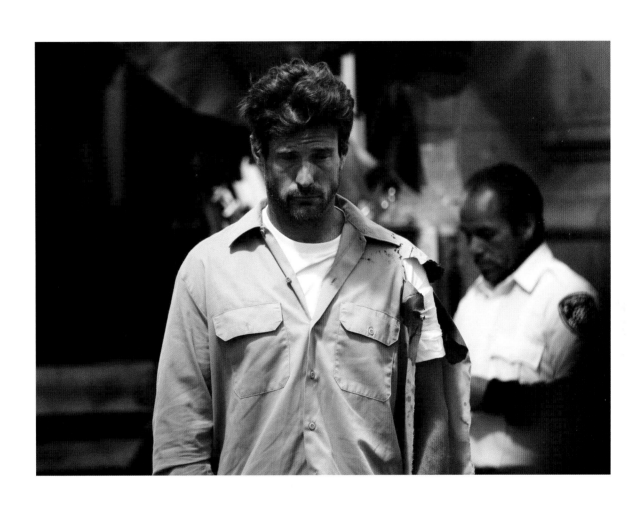

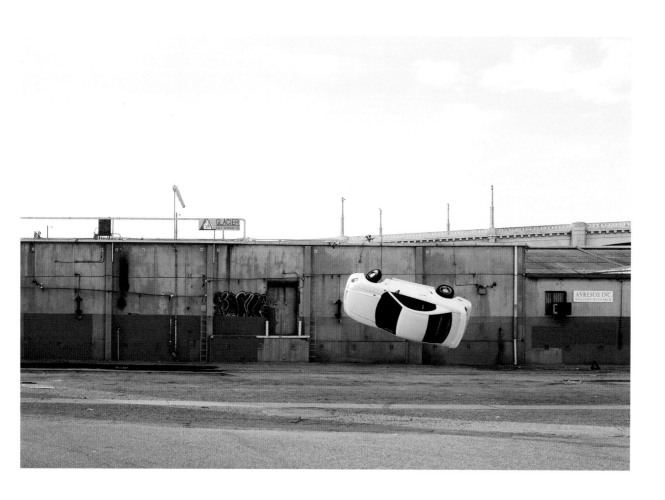

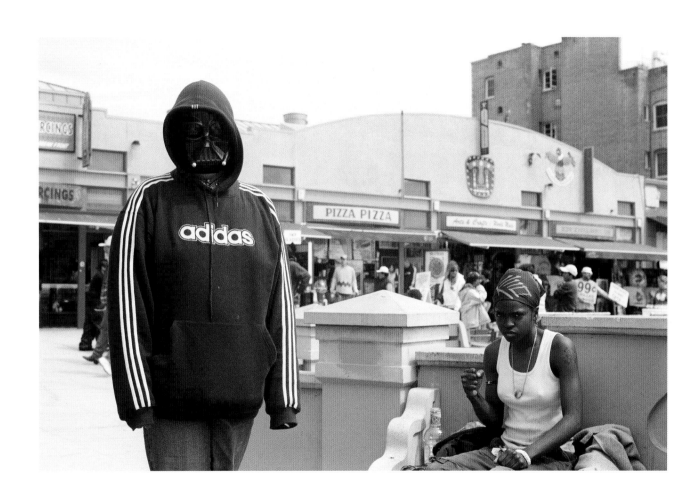

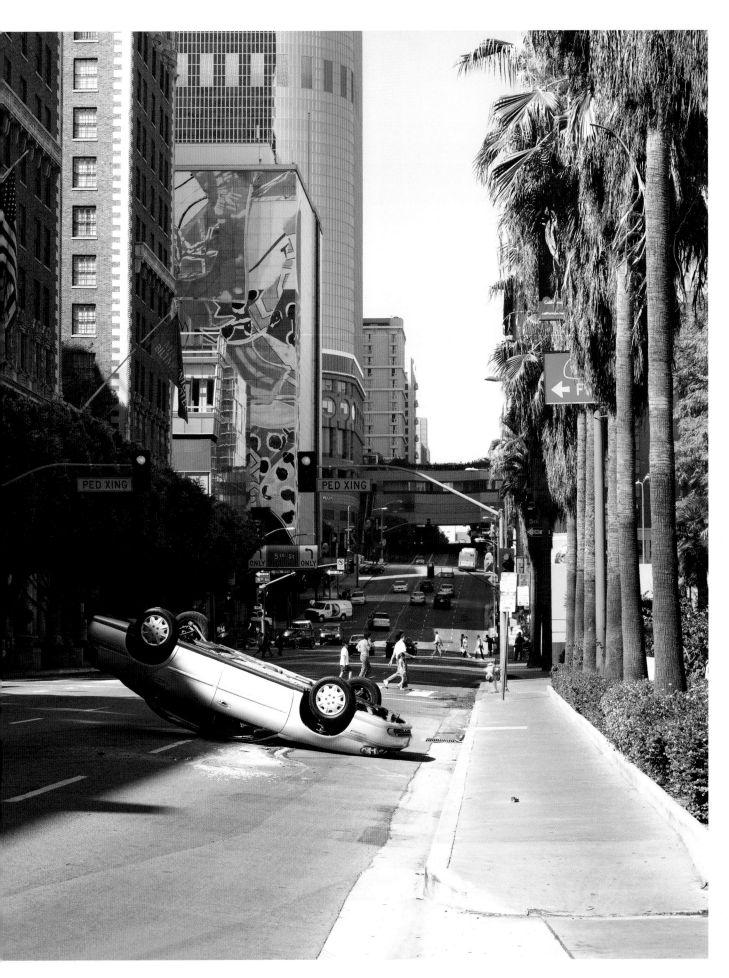

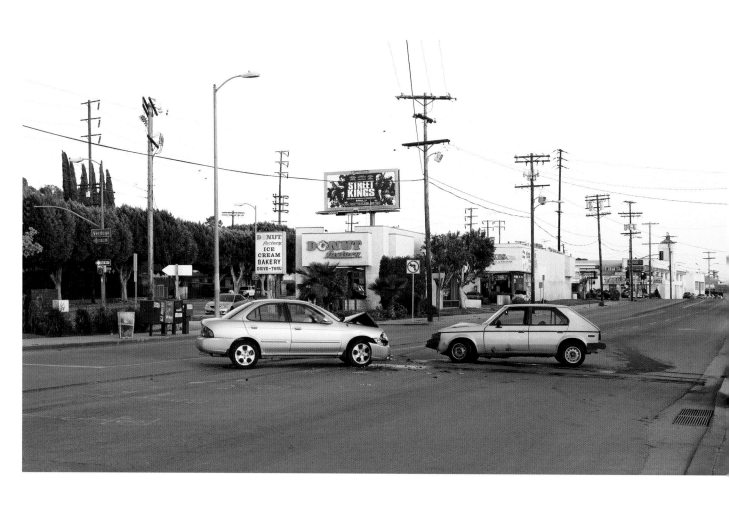

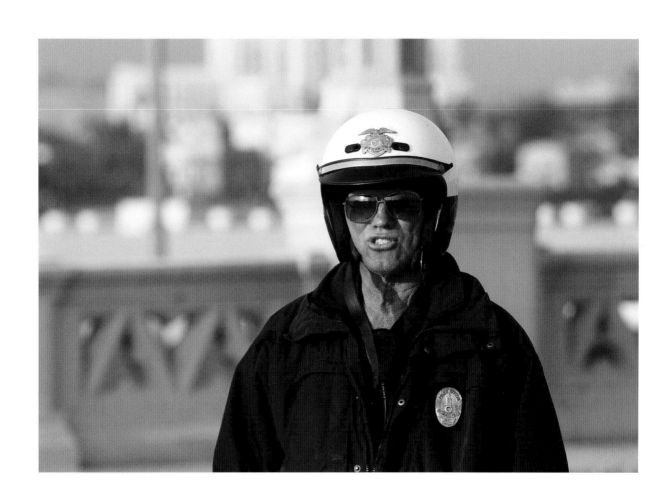

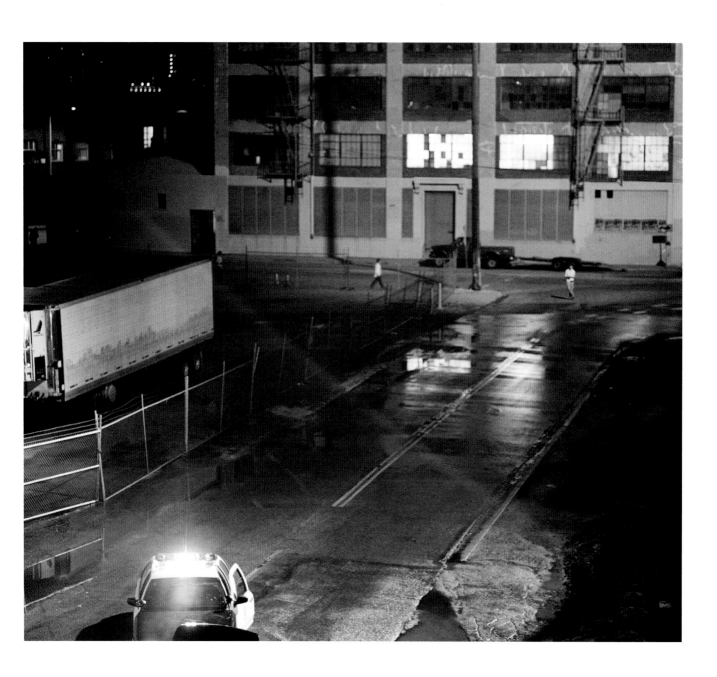

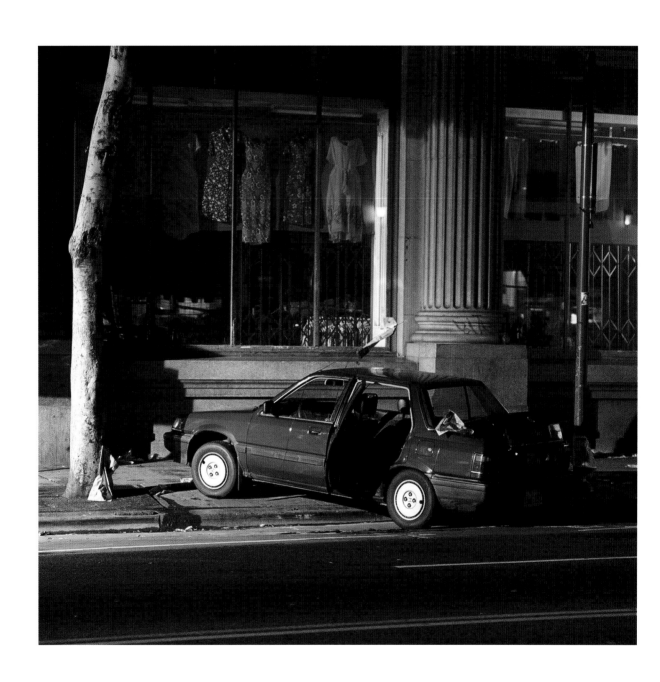

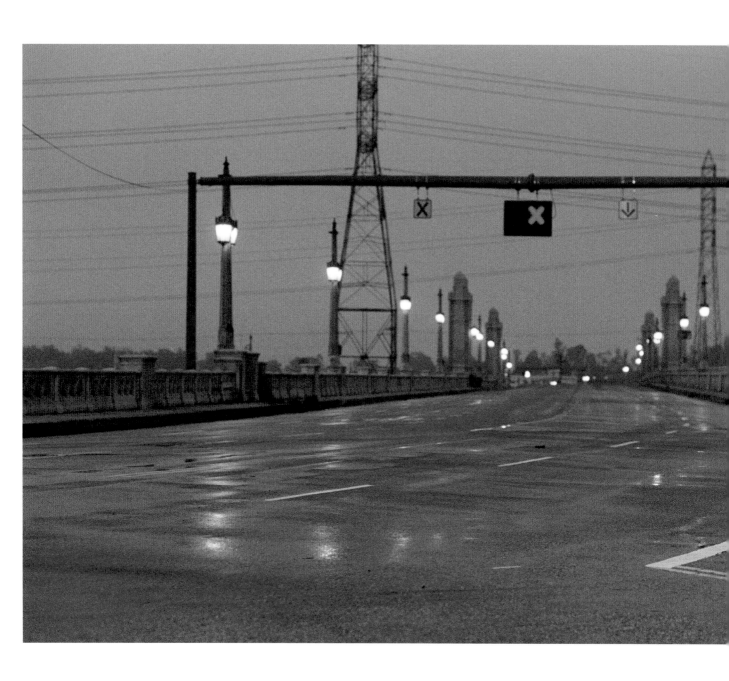

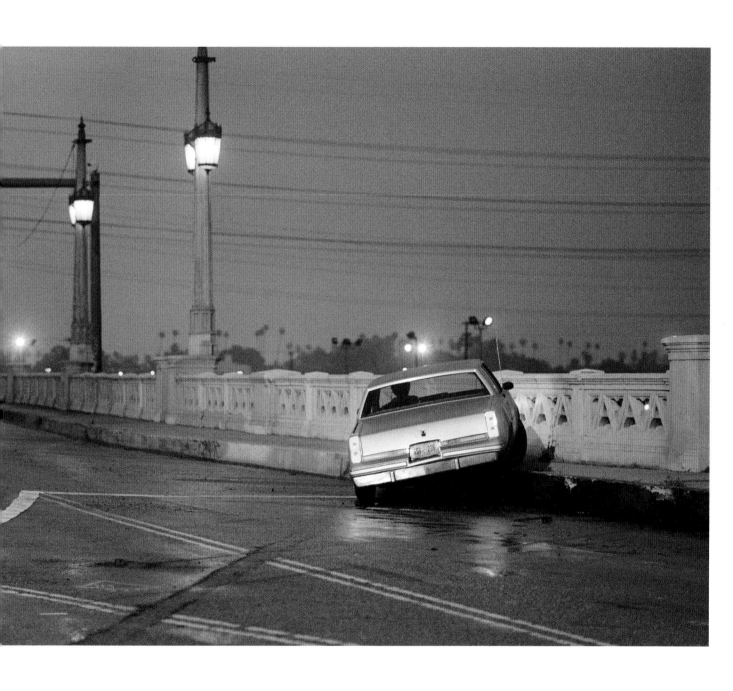

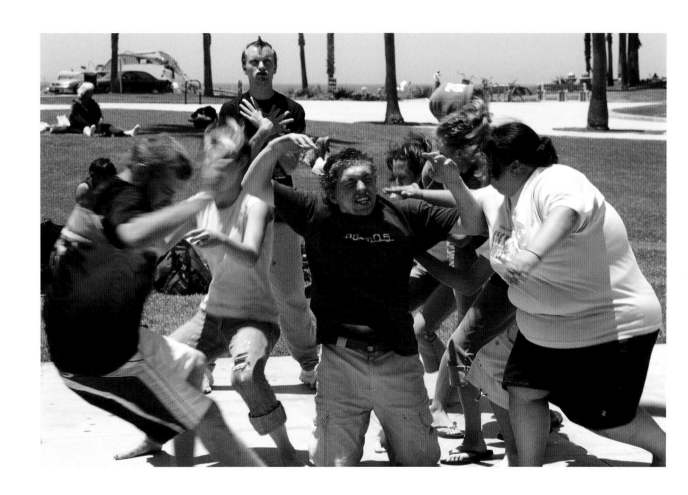

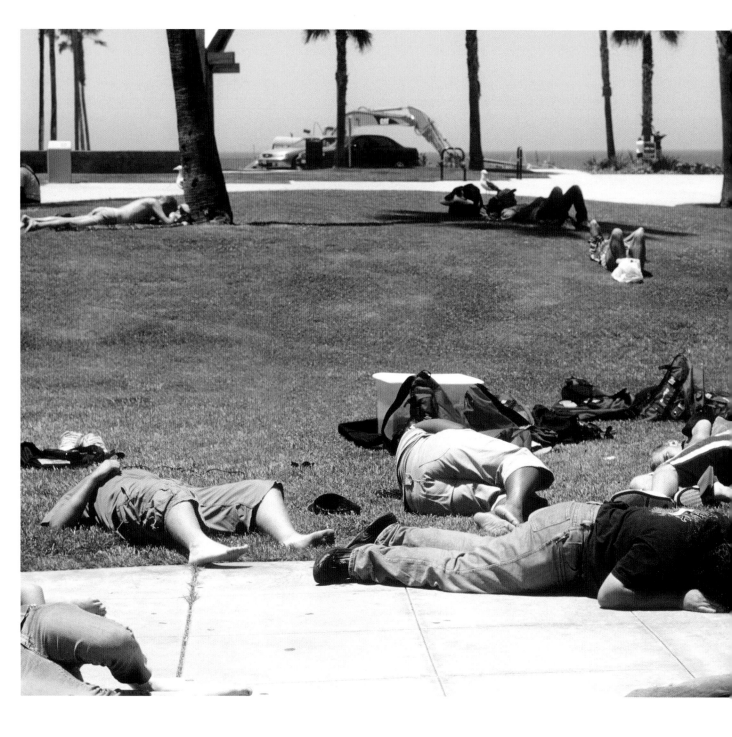

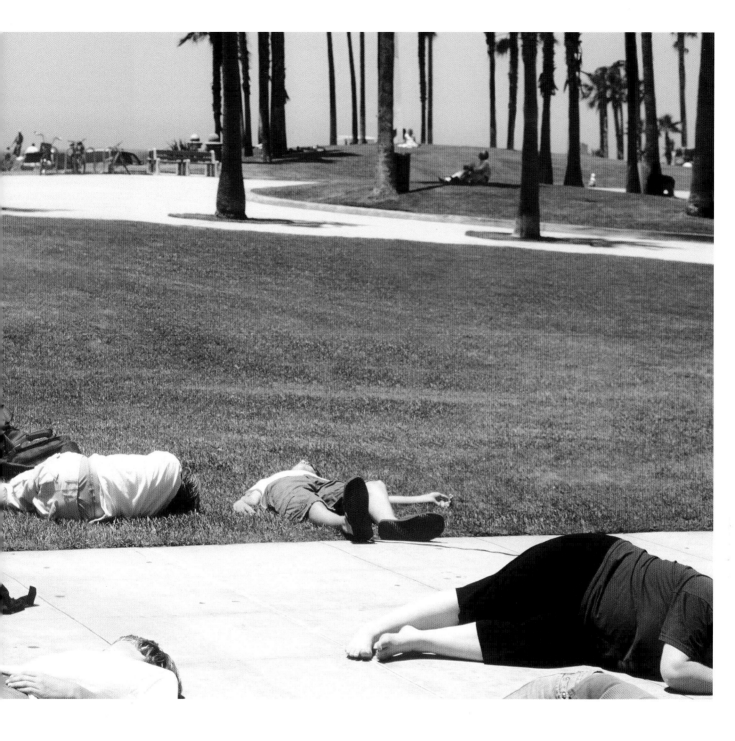

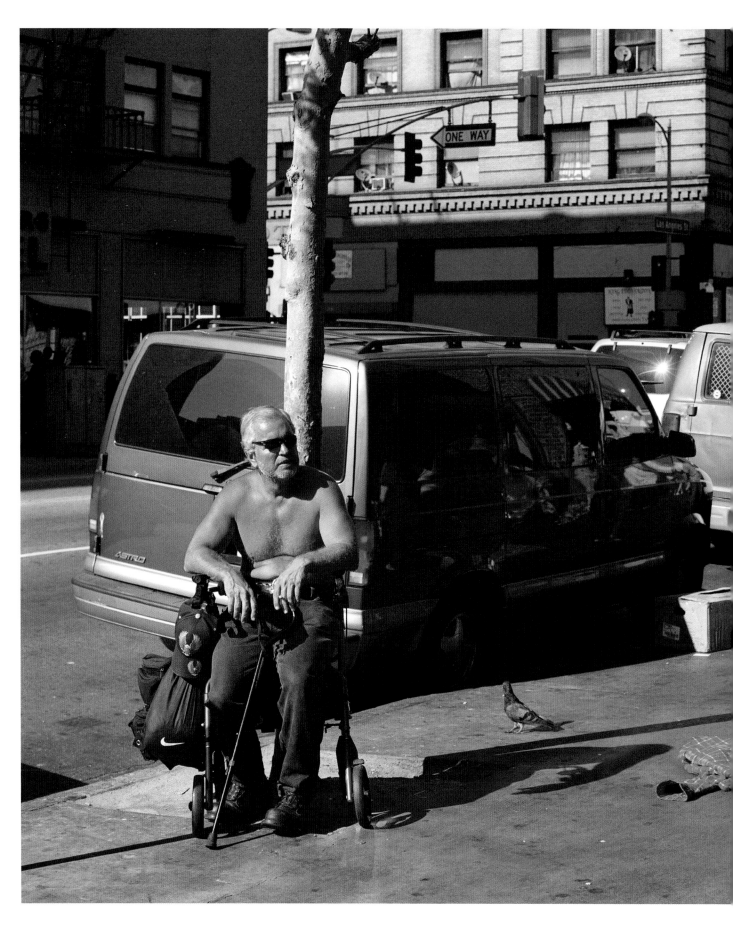

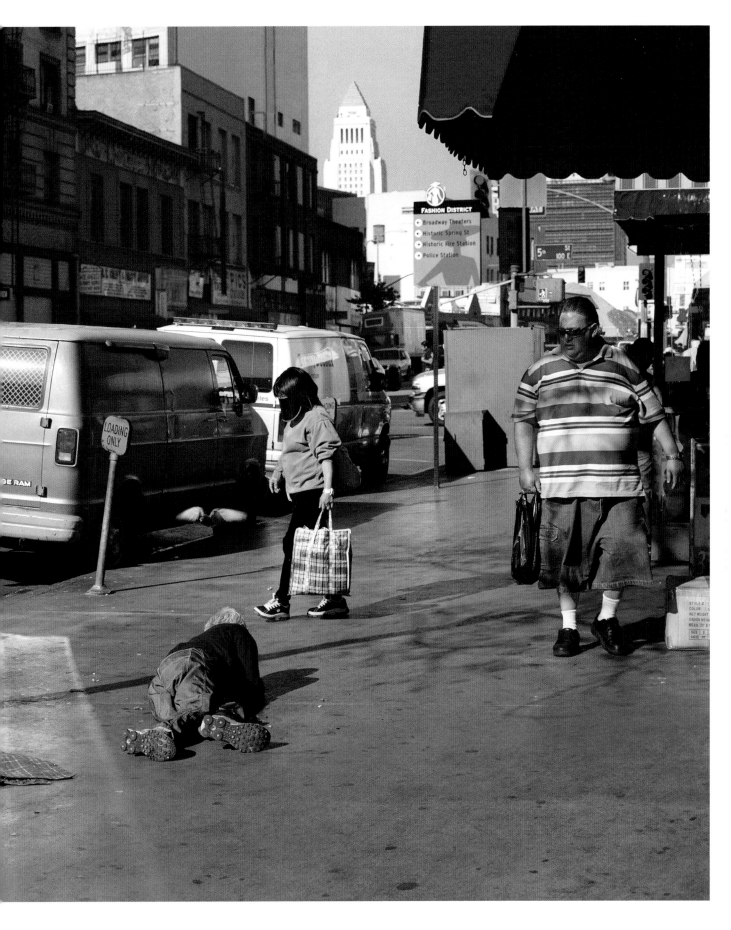

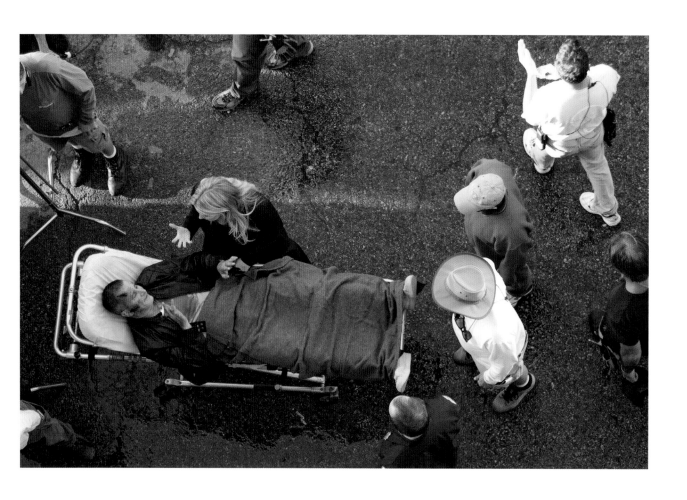

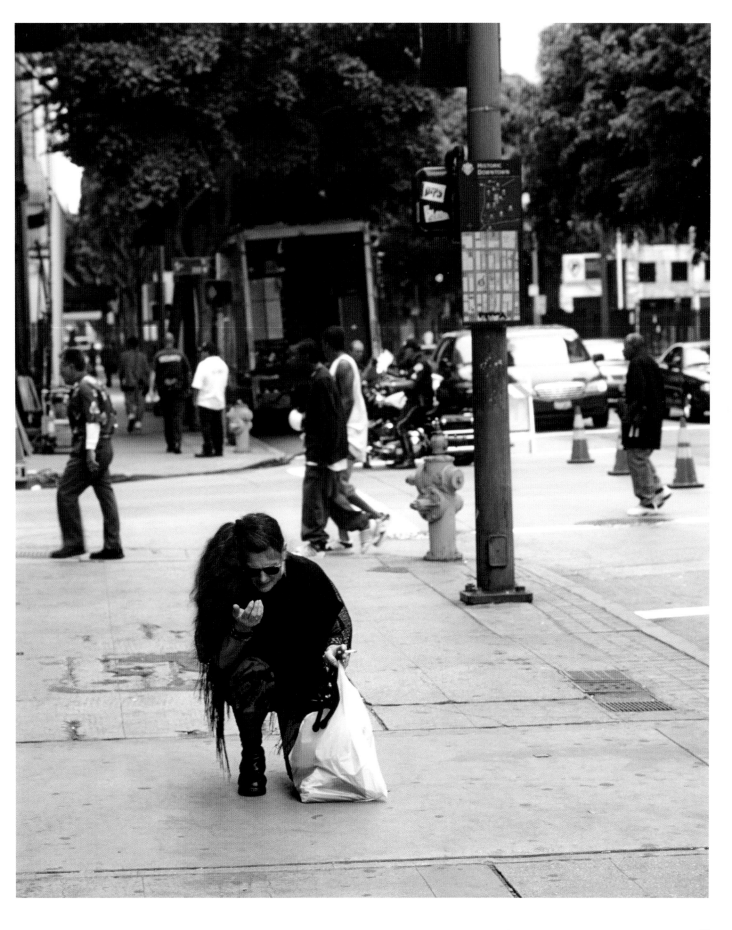

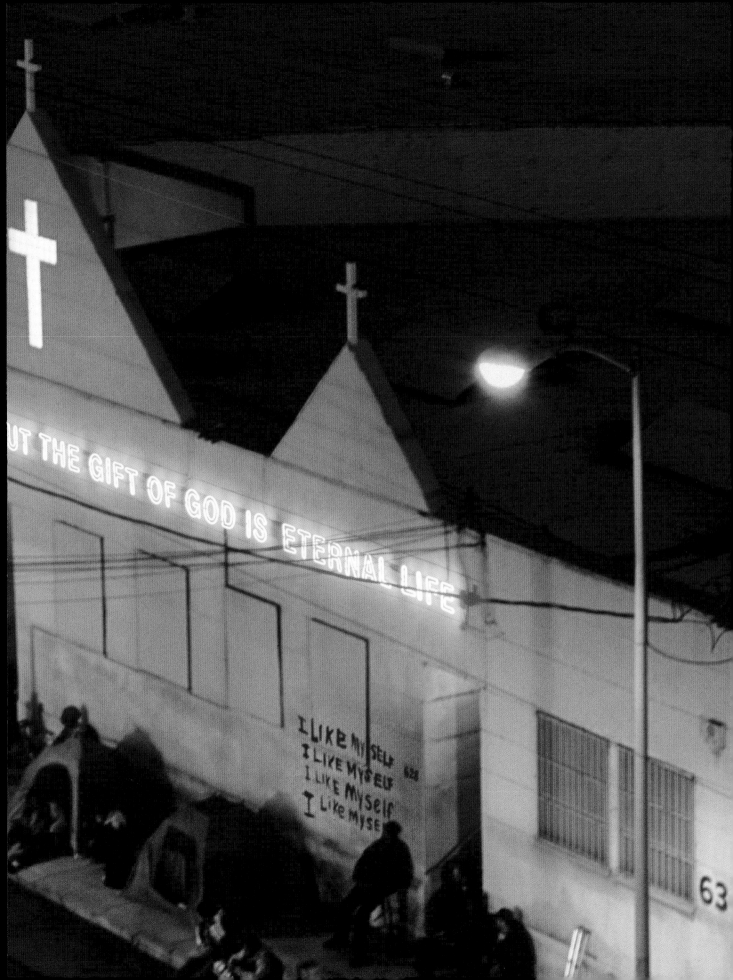

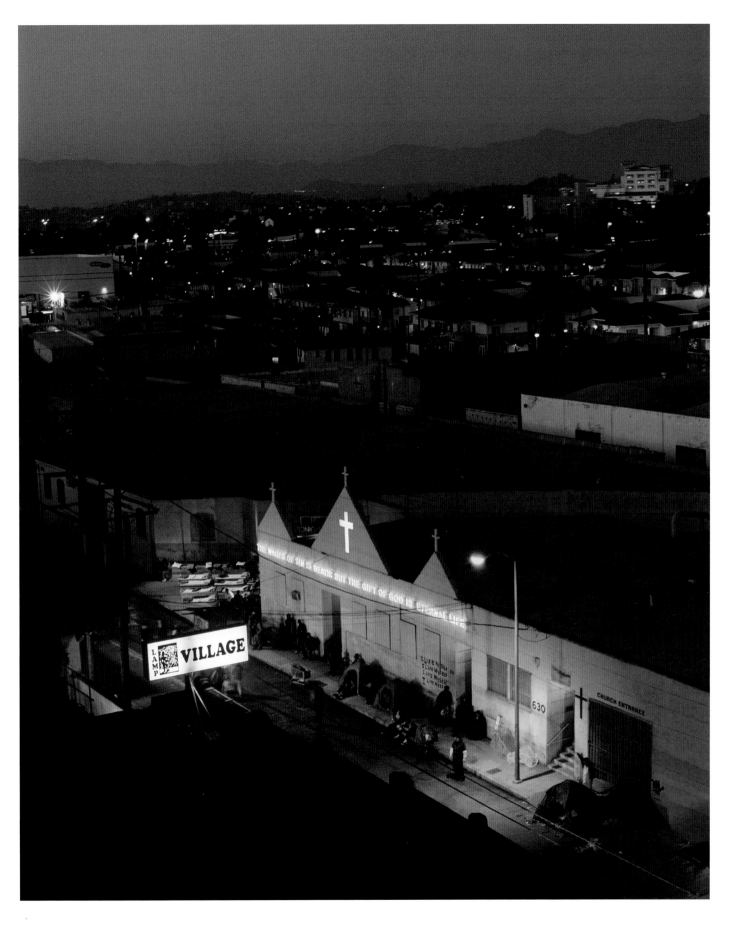

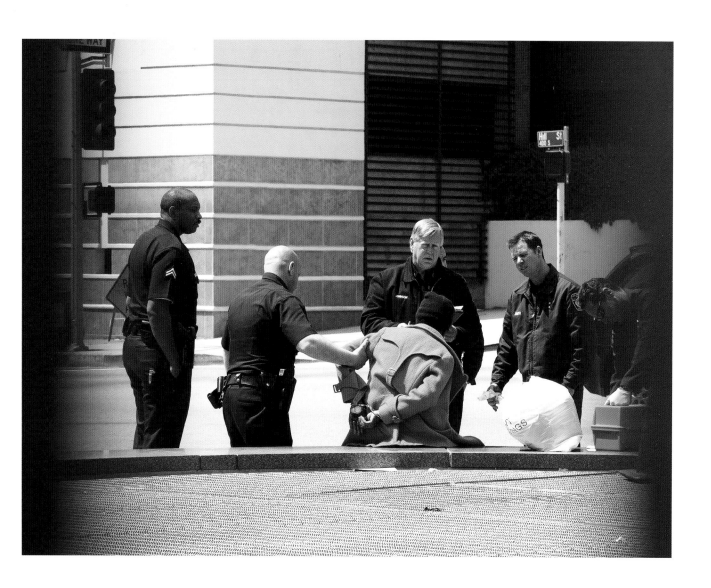

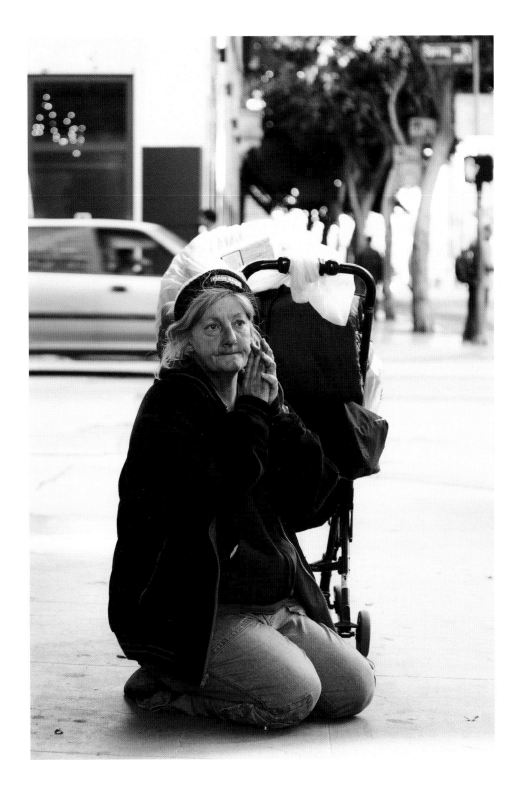

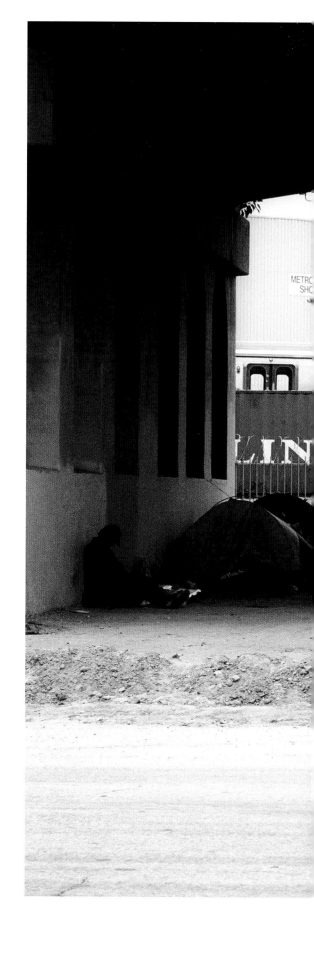

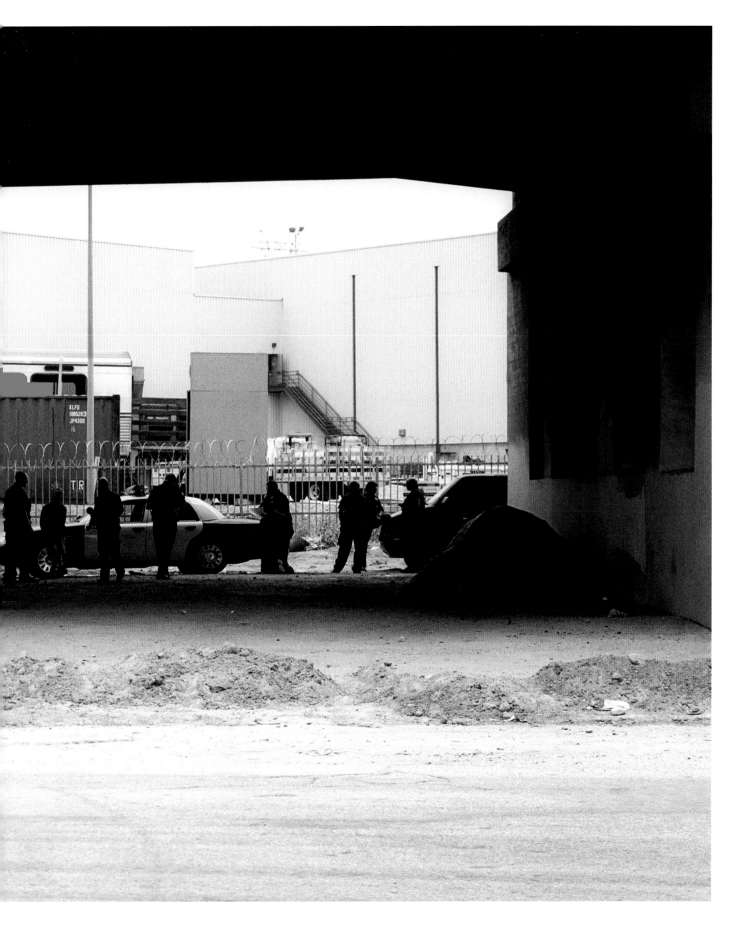

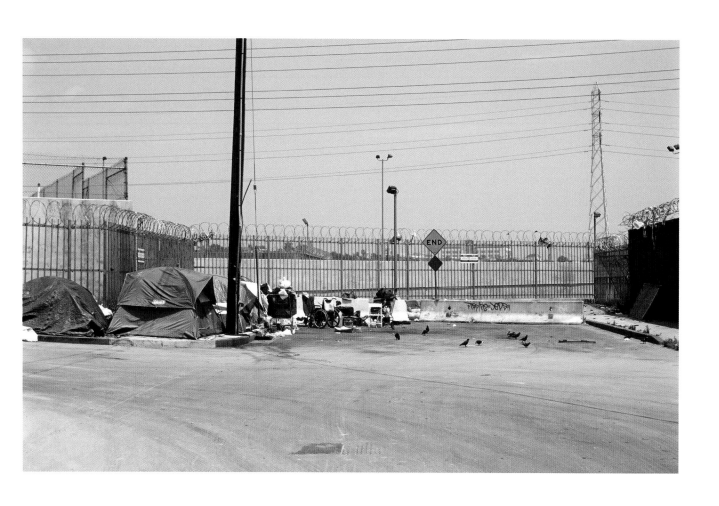

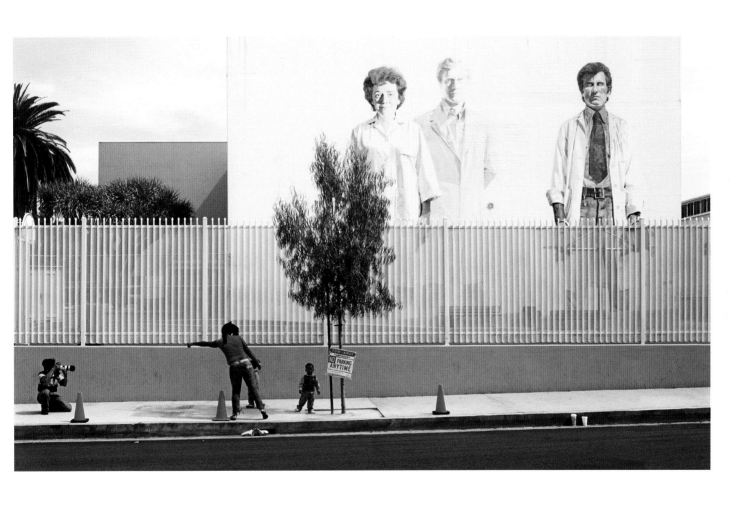

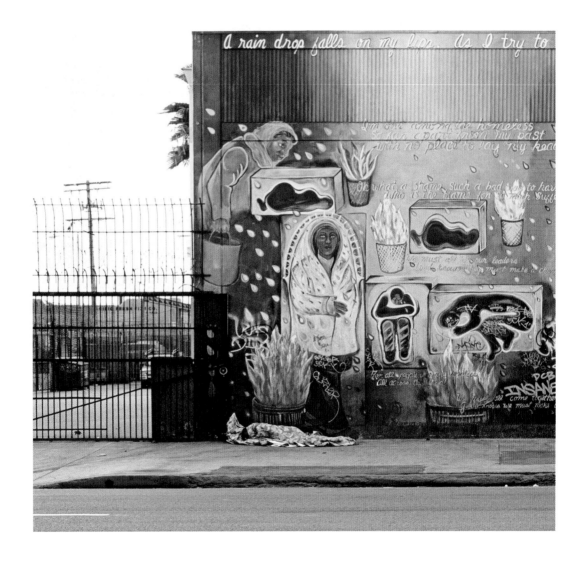

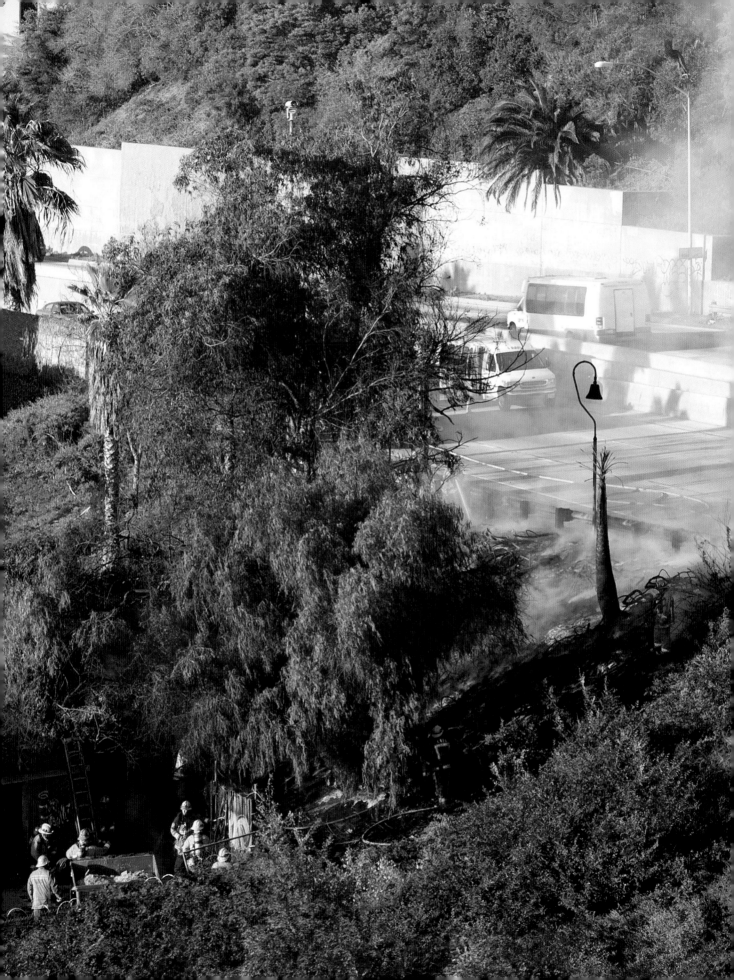

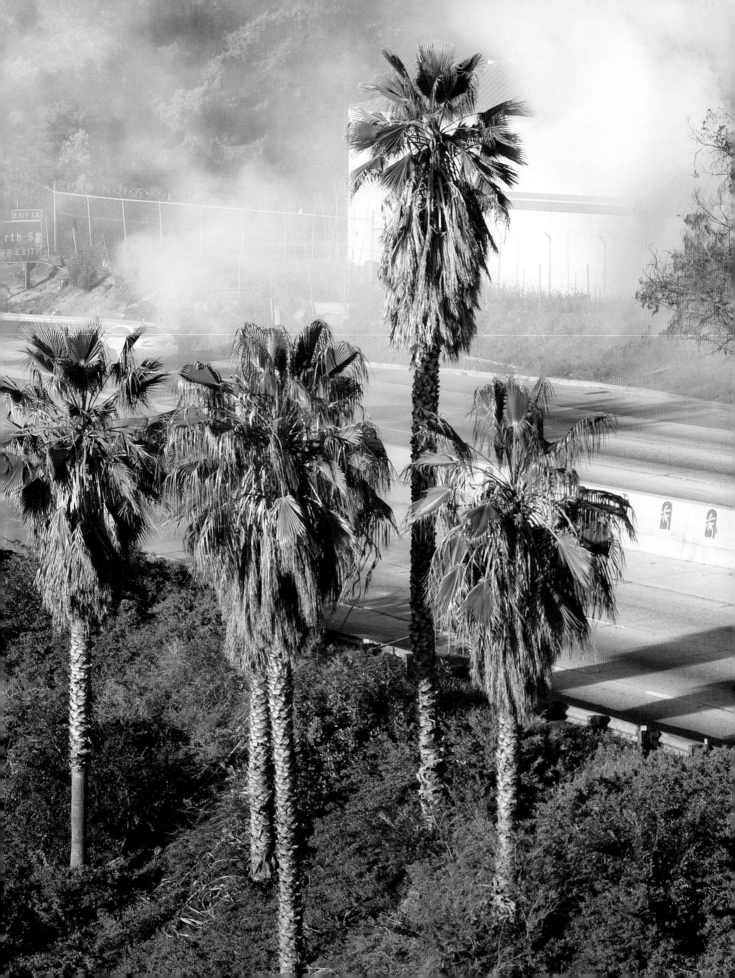

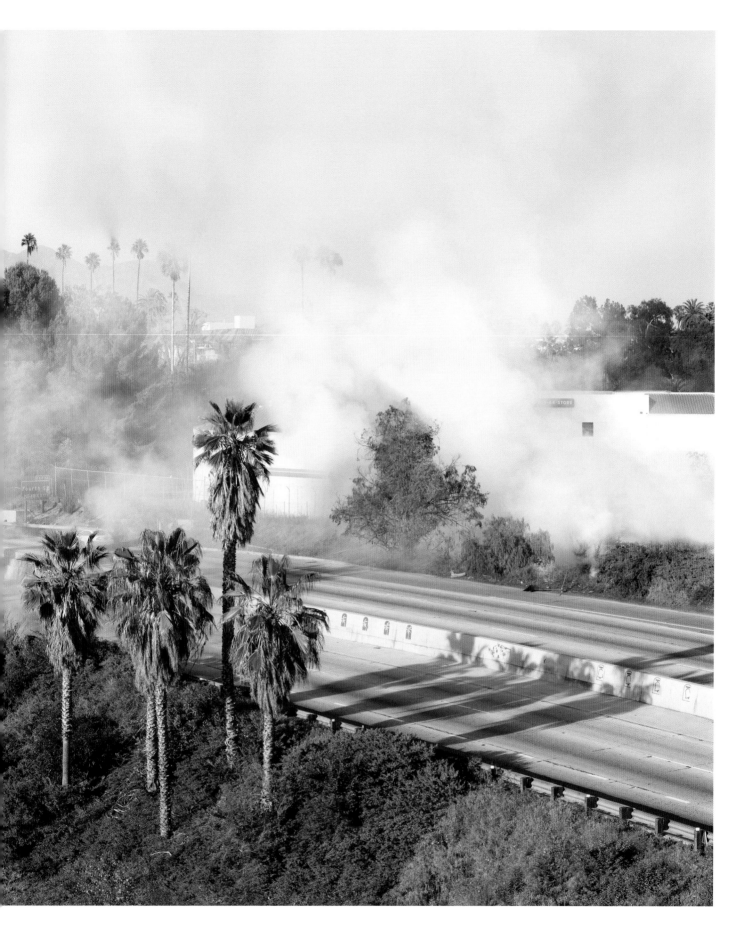

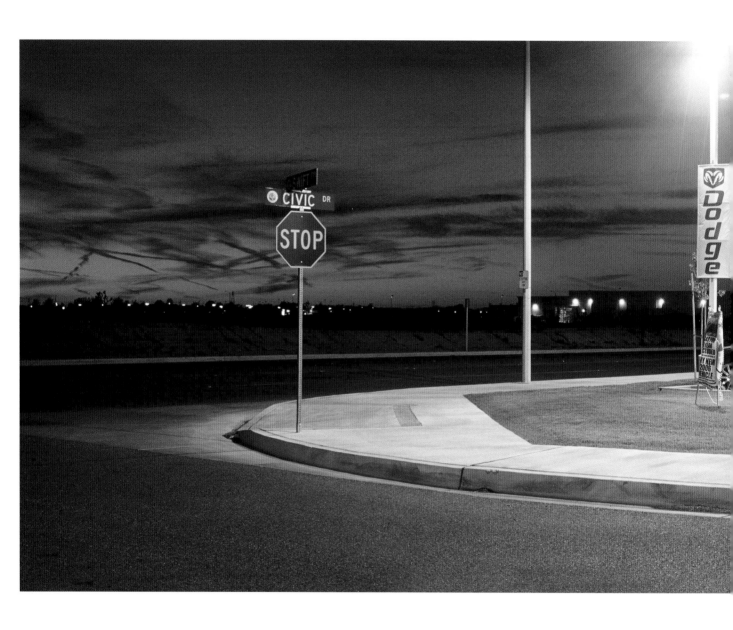

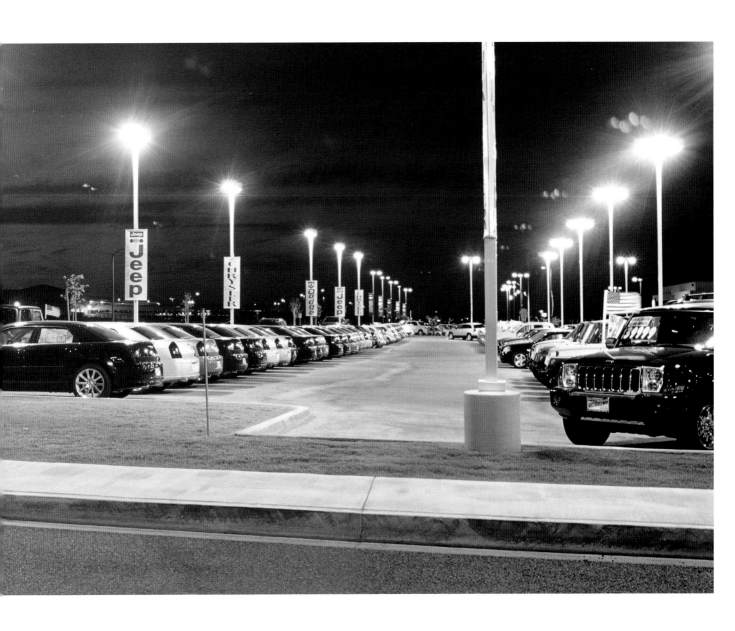

Biografie

1976	geboren in Sigmaringen
1996	Abitur in Müllheim/Baden
1996–97	Zivildienst in Heidelberg in einem Wohnheim für geistig Behinderte
1997–99	Studium der Physik an der Albert-Ludwigs-Universität Freiburg/Breisgau
1999–01	Ausbildung zum foto- und medientechnischen Assistenten in Freiburg
2001–07	Studium der Freien Kunst an der Hochschule für Bildende Künste Braunschweig bei den ProfessorInnen Friedemann von Stockhausen, Johannes Brus, Dörte Eißfeldt und Birgit Hein Diplom mit Auszeichnung 2007
2004	zusätzlich Nebenhörer bei Prof. Katharina Sieverding an der Universität der Künste Berlin
2005/06	Auslandsstudium am California Institute of the Arts, Los Angeles, School of Film & Video, MFA program
2007/08	Meisterschüler an der HBK Braunschweig bei Prof. Michael Brynntrup

Preise und Stipendien

2008	1. Preis, Aenne-Biermann-Preis für deutsche Gegenwartsfotografie
2007	Nordwestkunst, Preis der Kunsthalle Wilhelmshaven
	DAAD-Projektstipendium, Los Angeles
	Stipendium Junge Kunst der Alten Hansestadt Lemgo
2005/06	Fulbright-Jahresstipendium, California Institute of the Arts, Los Angeles
2004–08	Studienstiftung des deutschen Volkes

Einzelausstellungen

2008	»Tales from the West Side«, Museum Goch, 9.11.08–11.1.09
	»Die Preisträger der Nordwestkunst 2007«, Kunsthalle Wilhelmshaven, 28.9.–30.11.
	»scenic«, Galerie Eichenmüllerhaus Lemgo, 4.2.–2.3.
2007	»Block Episodes«, Kunstklub Berlin, 18.8.–2.9.

Gruppenausstellungen (Auswahl)

2008	»Nordlichter«, Herbstausstellung niedersächsischer Künstler, Kunstverein Hannover, 28.6.–17.8.
	»Aenne-Biermann-Preis«, Museum für Angewandte Kunst Gera, 29.1.–2.3.
2007	»Nordwestkunst 2007 – Die Nominierten«, Kunsthalle Wilhelmshaven, 29.4.–17.6.

	»Expanded Media«, Stuttgarter Filmwinter, Württembergischer Kunstverein Stuttgart, 18.1.–4.3.
	»Stipendium Junge Kunst – Wettbewerbsausstellung«, Galerie Eichenmüllerhaus Lemgo, 14.1.–28.1.
2006	»Höhepunkte der Kunstfilmbiennale Köln 2005«, Kunst-Werke Berlin, 24.9.–4.10.
	»Emprise Art Award«, Stadtmuseum Düsseldorf, 16.9.–1.10.
2005	»CalArts Projection Lab«, Schindler House, Los Angeles, 16.12.
	»Plattform #2«, Kunstverein Hannover, 5.–8.11.
2004	»Monitoring«, Kulturbahnhof Kassel, 10.–14.11.
2003	»Fremde.Orte.« Klasse Eißfeldt, Museum für Photographie Braunschweig, 15.6.–3.8.

Videoscreenings (Auswahl)

2007	International Kansk Video Festival, Kansk, Russland
	Ursula Blickle Videolounge, Kunsthalle Wien
	»The Territory«, Kurzfilmprogramm auf PBS (TV-Kanal), Texas, USA
2006	Media Art Festival Friesland, Niederlande
	Havenfilmfestival, Antwerpen, Belgien
	European Media Art Festival, Osnabrück (EMAF-Tourprogramm 2006/07)
	Screen Door Festival, Austin, Texas, USA
	Images Festival, Toronto, Kanada
	Traverse Vidéo, Toulouse, Frankreich
	»Einschnitte«, 30 Jahre Filmklasse Braunschweig, Niedersächsische Landesvertretung Berlin
2005	Ongoing-Festival, Stuttgart
	2nd International Video Reporting Award, Weimar
	Kunstfilmbiennale Köln
	Filmfest Braunschweig
	Cinematexas 10, Austin, Texas, USA
	COURTisane Short Film Festival, Gent, Belgien
	nepdoc. Jugend- und Dokumentarfilmfestival Reutlingen
2004	Kasseler Dokumentarfilm- und Videofest

Biography

1976	born in Sigmaringen, Germany
1996	High school graduation (Abitur) in Müllheim/Baden, Germany
1996–97	Civilian service in Heidelberg in a home for the mentally disabled
1997–99	Studies of physics at the Albert-Ludwigs-University Freiburg, Germany
1999–01	Vocational training as a photographic and media technical assistant in Freiburg, Germany
2001–07	Studies of Fine Arts at the Braunschweig University of Art, Germany, under professors Friedemann von Stockhausen, Johannes Brus, Dörte Eißfeldt and Birgit Hein Graduation (Diploma) with distinction 2007
2004	Visiting student, class of Prof. Katharina Sieverding, Berlin University of the Arts
2005/06	Exchange year at the California Institute of the Arts, Los Angeles, School of Film & Video, MFA program
2007/08	"Meisterschüler" (postgraduate study program) at the Braunschweig University of Art under Prof. Michael Brynntrup

Scholarships and Awards

2008	First Prize, Aenne Biermann Prize for contemporary German photography
2007	Nordwestkunst, Prize of the Kunsthalle Wilhelmshaven, Germany DAAD travel grant, Los Angeles Yearlong residency scholarship, Lemgo, Germany
2005/06	Fulbright scholarship, California Institute of the Arts, Los Angeles (yearlong fellowship)
2004–08	Scholarship of the "Studienstiftung des deutschen Volkes" (National scholarship award)

Solo Exhibitions

2008	"Tales from the West Side," Museum Goch, Germany, 11/9/08–1/11/09 "The Award Winners of Nordwestkunst 2007," Kunsthalle Wilhelmshaven, Germany, 9/28–11/30 "scenic," Gallery Eichenmüllerhaus Lemgo, Germany, 2/4–3/2
2007	"Block Episodes," Kunstklub Berlin, 8/18–9/2

Selected Group Exhibitions

2008	"Northern Lights," 84th Fall Exhibition, Kunstverein Hanover, Germany, 6/28–8/17

	"Aenne Biermann Prize," Museum for Applied Arts, Gera, Germany, 1/29–3/2
2007	"Nordwestkunst 2007–The Nominees," Kunsthalle Wilhelmshaven, Germany, 4/29–6/17 "Expanded Media," Film winter Stuttgart, Württembergischer Kunstverein Stuttgart, Germany, 1/18–3/4 "Scholarship Young Art–Competition show," Gallery Eichenmüllerhaus Lemgo, Germany, 1/14–1/28
2006	"Highlights of the Kunstfilmbiennale Cologne 2005," KW Institute for Contemporary Art, Berlin, 9/24–10/4 "Emprise Art Award," Stadtmuseum Düsseldorf, Germany, 9/16–10/1
2005	"CalArts Projection Lab," Schindler House, Los Angeles, 12/16 "Platform #2," Kunstverein Hanover, Germany, 11/5–11/8
2004	"Monitoring," Kulturbahnhof Kassel, Germany, 11/10–11/14
2003	"Fremde.Orte." Class of Prof. Eißfeldt, Museum of Photography Braunschweig, Germany, 6/15–8/3

Selected Screenings

2007	International Kansk Video Festival, Kansk, Russia Ursula Blickle video lounge, Kunsthalle Wien, Vienna "The Territory," PBS (TV-Channel), Texas, USA
2006	Media Art Festival Friesland, The Netherlands Havenfilmfestival, Antwerp, Belgium European Media Art Festival, Osnabrück, Germany (EMAF tour program 2006/07) Screen Door Festival, Austin, Texas, USA Images Festival, Toronto, Canada Traverse Vidéo, Toulouse, France "Insections," 30 years of film class Braunschweig, Lower Saxony Representation, Berlin
2005	Ongoing-Festival, Stuttgart, Germany 2nd International Video Reporting Award, Weimar, Germany Kunstfilmbiennale, Cologne, Germany Film Festival Braunschweig, Germany Cinematexas 10, Austin, Texas, USA COURTisane Short Film Festival, Ghent, Belgium nepdoc, Documentary Film Festival Reutlingen, Germany
2004	Kassel Documentary Film & Video Festival, Germany

Abbildungsverzeichnis List of Illustrations

Flow (Seite/page 8, 14)
Videoinstallation: Einzelprojektion, Farbe, ohne Ton
Video installation: Single projection, color, silent
7:15 min, Loop, 2007
Größe der Projektion/**Size of projection:** 75 × 100 cm

L.A. Crash (Seite/**page** 86)
Ausstellungsansicht /**Exhibition view**

L.A. Crash
Lambdaprints, gerahmt/**Lambda prints, framed**
2006–2008

Bildmaße der abgebildeten Fotografien in cm
Size of the photographs in cm

Seite page	Bildgröße size	Jahr year
17	80 × 80	2006
18	30 × 45	2008
19	25 × 35	2008
20	35 × 50	2008
21	40 × 65	2008
22–25	120 × 155	2008
26	35 × 45	2008
27	75 × 50	2006
28	50 × 70	2006
29	35 × 45	2008
30–31	120 × 150	2008
32–35	120 × 185	2008
36	30 × 45	2006
37	70 × 110	2006
39	45 × 70	2008
40–41	35 × 80	2006
42	90 × 125	2008
43	30 × 45	2008
44	55 × 80	2008
45	50 × 75	2006
46–47	90 × 95	2008
48	45 × 80	2008
49	30 × 40	2008
50	95 × 110	2006
51	50 × 55	2006
52–53	45 × 115	2006
55	40 × 60	2006
56–57	35 × 75	2006
58–59	85 × 145	2008
60	35 × 50	2008
61	35 × 50	2006
63	60 × 50	2006
64–67	135 × 110	2008
68	45 × 60	2008
69	50 × 35	2008
70–71	80 × 100	2006
72	70 × 110	2006
73	30 × 50	2006
75	50 × 50	2008
76–79	80 × 100	2008
80–81	65 × 180	2006
82–83	70 × 100	2006

Mirko Martin

Tales from the West Side

Herausgegeben von / **Edited by** Stephan Mann, Museum Goch

● ● ●

Museum Goch

● ● ●

● ● ●

Dieses Buch erscheint anlässlich der Ausstellung im
Museum Goch, 9. November 2008 bis 11. Januar 2009.
This book is published on the occasion of the exhibition at
Museum Goch from 9th November 2008 to 11th January 2009.

Redaktion / **Compilation**
Steffen Fischer
Stephan Mann

Text
Martin Engler
Stephan Mann

Übersetzung / **Translation**
Rhodes Barrett, Berlin

Fotos / **Photographs**
Mirko Martin

Gestaltung & Satz / **Graphic design & typesetting**
hackenschuh com. design, Stuttgart
Christina Hackenschuh, Markus Braun

Herstellung / **Production**
B.o.s.s Druck und Medien GmbH, Goch

Die Deutsche Nationalbibliothek verzeichnet diese Publikation in der
Deutschen Nationalbibliografie; detaillierte bibliografische Daten
sind im Internet über http://dnb.ddb.de abrufbar.
The Deutsche Nationalbibliothek holds a record of this publication in the
Deutsche Nationalbibliografie; detailed bibliographical data can be
found under: http://dnb.ddb.de.

Publisher and Distribution
Kerber Verlag, Bielefeld
Windelsbleicher Str. 166–170
33659 Bielefeld
Germany
Tel. +49 (0) 5 21/9 50 08-10
Fax +49 (0) 5 21/9 50 08-88
E-mail: info@kerberverlag.com
www.kerberverlag.com

Kerber, US Distribution
D.A.P., Distributed Art Publishers Inc.
155 Sixth Avenue 2nd Floor
New York, N. Y. 10013
Tel. +1 212 6 27-19 99
Fax +1 212 6 27-94 84

© 2008 Kerber Verlag, Bielefeld/Leipzig,
Autoren, Herausgeber und Künstler
Authors, Publisher and Artist

ISBN 978-3-86678-229-7
Printed in Germany

Mit freundlicher Unterstützung / **Kindly supported by**

Sparkasse
Goch-Kevelaer-Weeze